IMAGES
of America

LYME

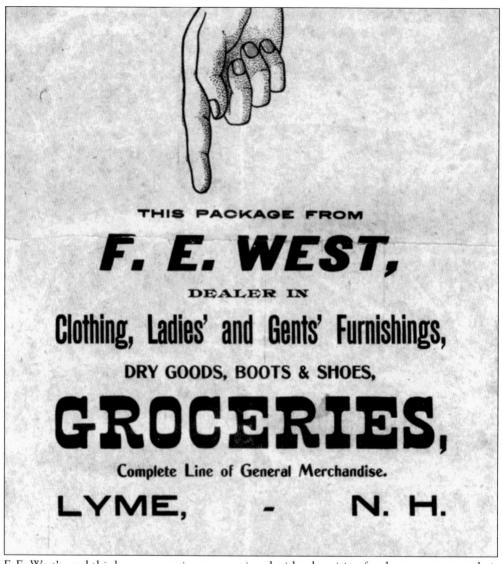

THIS PACKAGE FROM

F. E. WEST,

DEALER IN

Clothing, Ladies' and Gents' Furnishings,

DRY GOODS, BOOTS & SHOES,

GROCERIES,

Complete Line of General Merchandise.

LYME, - N. H.

F. E. West's used this brown wrapping paper printed with advertising for the store to wrap their customers' purchases.

On the cover: F. E. West's general store was on the north side of the common from 1906 to 1944. Pictured between the star and flag–draped columns are, from left to right, the postmaster, P. H. Claflin; Walter Lamphere; store owners Frank and Jennie West; and clerks Luther Whittemore and Millie West. (Courtesy of the Lyme Historians.)

IMAGES
of America

LYME

Jane Fant, Sallie Ramsden, and Judy Russell

ARCADIA
PUBLISHING

Published by Arcadia Publishing
Charleston SC, Chicago IL, Portsmouth NH, San Francisco CA

Printed in the United States of America

Library of Congress Catalog Card Number: 2006931505

For all general information contact Arcadia Publishing at:
Telephone 843-853-2070
Fax 843-853-0044
E-mail sales@arcadiapublishing.com
For customer service and orders:
Toll-Free 1-888-313-2665

Visit us on the Internet at www.arcadiapublishing.com

This book is dedicated to
Pauline (1906–1995), right,
and Ruth Whittemore
(1909–2005). Born in
Lyme at Maple Grove
Farm on Washburn Hill,
they devoted countless
hours to the preservation
of Lyme's historical records
and photographs.

CONTENTS

ACKNOWLEDGMENTS

The authors would like to thank the following people who so generously made pictorial or other historical materials available for our use in this book: Hugh Alley, Alfred Balch, Charles and Mertie Balch, Nancy Clark, Rev. Gregory Dimick, Don and Julia Elder, James Fields, John Franklin, Charlotte LaMott, Verna Rich, Chris Schonenberger, Dorothy Sears, the Town of Lyme, and the Rauner Special Collections Library at Dartmouth College.

Tribute is also due to "pioneer" photographers Angie Lambert, Anna Webster, George Harwood, Hattie Wise, and many families who recorded life in Lyme in the past. Our gratitude goes to the group of dedicated citizens who founded the Lyme Historians in 1961, saved and identified the photographs, and took the time to commit their knowledge and memories to paper.

We relied heavily on *Patterns and Pieces,* the history of Lyme, edited by Luane Cole in 1976, for many details of these past events.

INTRODUCTION

When the first settlers came to Lyme in 1764, no cameras recorded their faces or their struggles to tame the wilderness. Portraits, paintings, and written documents from that time reveal much but leave more to the imagination. The average family hacking a farm out of the forest had no money for portraits even if artists were available. And for centuries before New Hampshire's Royal Gov. Benning Wentworth granted Lyme's charter in 1761, the area had been home to the Abenaki Indians. Of them, we have even fewer records.

The families moving north to Lyme (Lime, as it was spelled in early records) were mostly of English descent. By 1781, there were some 57 dwellings and a meetinghouse. By 1790, the first census conducted by the newly independent United States counted 816 people in Lyme. Only 30 years later, Lyme's population reached its high-water mark of 1,824, which held for around 10 years and then began to decline.

By the time the first photographs were taken, the Civil War was looming and Lyme's farmers had already shifted their focus from crops to sheep. As sheep farming gradually became unprofitable, dairy farming increased. Throughout all these years, lumbering was a major endeavor and source of income, and the streams of Lyme powered mills and factories of all descriptions.

Even as the daily life of Lyme began to be documented in pictures, railroads were making it easier for young people to migrate to factory work, and the Erie Canal was making it easier to head west to richer, less rocky farmland. Many farms were abandoned, especially in the hills, and the dwindling population concentrated in the valleys, along brooks, and in Lyme Plain and Lyme Center. Neighborhoods were close-knit, and ties to towns across the Connecticut River were strong. Although musical and educational programs sometimes came from "outside," entertainment was usually home grown.

The hundreds of photographs in this book span the defining years in our history from just before the Civil War through the Depression and world wars. Although the town was shrinking in numbers, it was clearly an industrious, forward-looking community that valued work, family, friendship, religion, education, and fun. These pictures supplement those published in 1976 in *Patterns and Pieces*, a detailed history of the town. They help bring to life the experiences chronicled in *We Had Each Other*, an oral history published in 2000 by the Friends of the Lyme Library. But above all, they speak for themselves.

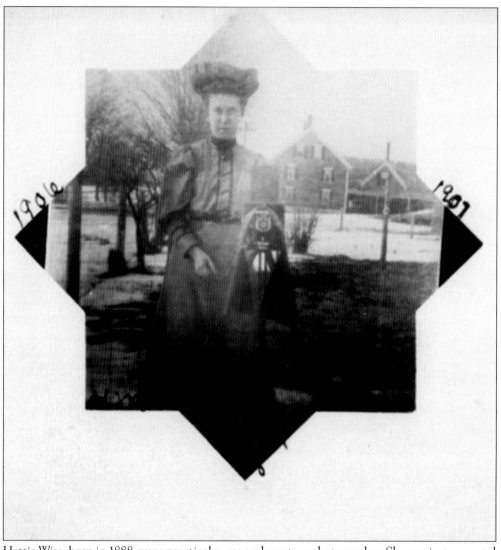

Hattie Wise, born in 1888, was a practical nurse and amateur photographer. She was instrumental in shaping the Lyme Home Health Agency. She was also an early member of the Lyme Historians. Her pictures with captions appear throughout this book.

One

LYME PLAIN AND COUNTRYSIDE

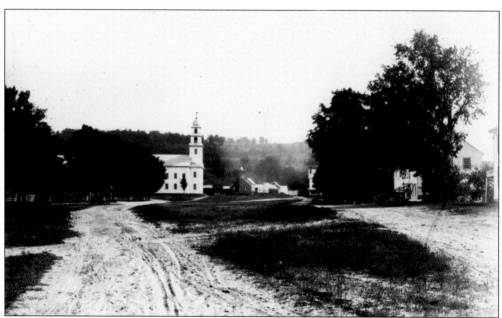

The center of Lyme Plain was not always the tidy place it became. For years, it was a hay field, mowed once or twice a summer. In approximately 1885, the roads bordering the common were not straight, and the grass not manicured. Until 1895, it was crisscrossed by eight roads and several paths. Looking east, one sees the Lyme Congregational Church built from 1808 to 1811, a corner of the horse sheds that still exist, and also the Brick School and another row of "white" horse sheds bordering Dorchester Road, later demolished. On the right, the sign for Wilmot's harness shop is barely visible, and the debris farther along may originate from the Pipers' diversified carpentry business and mill.

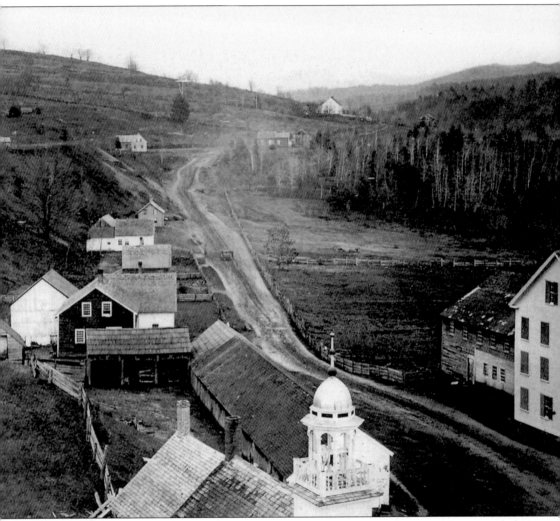

This is currently the oldest known photograph of Lyme, dating from about 1853. It was taken from the Lyme Congregational Church tower and looks east up Dorchester Road, over the adjacent tower of the Brick School and "white" horse sheds, with the 1809 Grant Tavern (later the Alden Inn) across from the school.

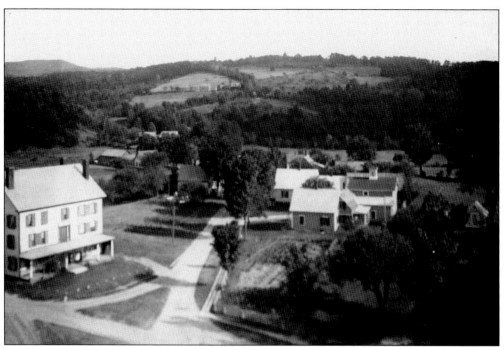

This picture looks south to Market Street from the church tower in the early 1900s. Blood's slaughterhouse and meat market were on Market Street just across Grant Brook.

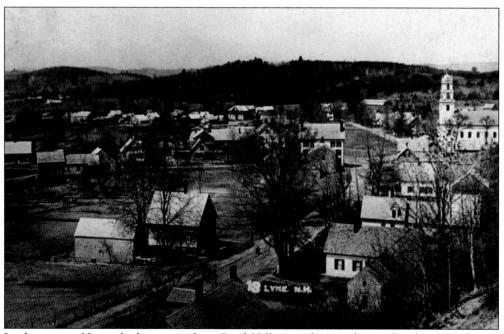

In this view of Lyme looking west from Sand Hill around 1910, the south side of Dorchester Road still has only one dwelling, the Elum Gilbert house and barn, built in 1854. The stretch of Dorchester Road from the church up past the High Street intersection was called Sand Hill because there was a sand pit.

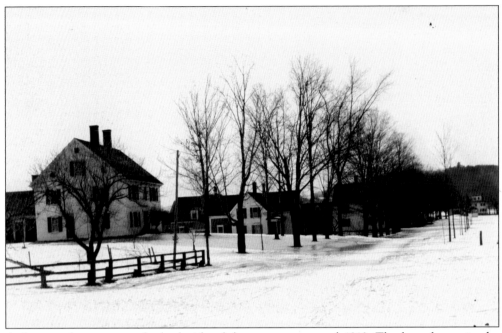

A dusting of snow coats the back side of the common around 1910. The large house in the foreground was built in 1793 by Rufus Conant, who lived there 61 years. He sold a piece of his land to the town for 6£ to form the east end of the common. Allegedly a peddler in Massachusetts, Rufus prospered after moving to Lyme in 1780—three years after witnessing the surrender of General Burgoyne at Saratoga. In 1790, Rufus and a cousin, Arthur Latham, took over the Lyme general store, which had been built by their uncle Jonathan Conant.

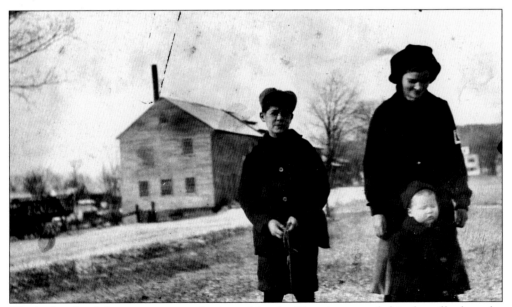

The back side of the common was dominated by the Pipers' saw- and shingle mill when the Webbs (left to right), Clark, Charlotte, and Harold, had this picture taken. Harold later became manager of the Lyme Creamery.

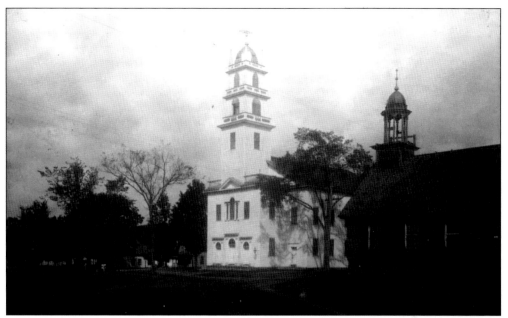

This is a good picture of the Brick School, which stood near the church from 1835 until 1914. In 1906, following a two-vote majority decision in the town meeting, it was closed and sold because the repairs were deemed too expensive. The pupils moved to the red school, which was new that year. The old school's bell was saved when the building was torn down in 1914 and is displayed today in front of the Lyme Elementary School.

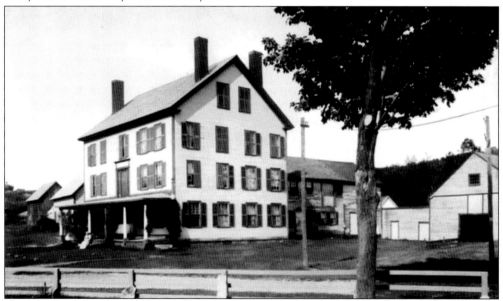

In 1809, the Grant Hotel was built by Salmon Washburn, a grandson of Capt. John Sloan, one of Lyme's first settlers. Erastus Grant bought it and then enlarged it in 1839. During the 1800s, the hotel accommodated residential as well as transient guests and hosted regular dances, Grange meetings, various social functions, and sometimes businesses. Toward the end of the century, it changed ownership twice and was used as an apartment house. In 1918, the Aldens bought and renamed it.

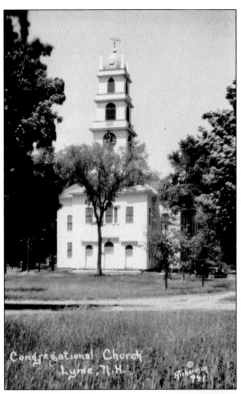

Congregational Church
Lyme, N.H.

The Lyme Congregational Church, a Lyme landmark, was financed by selling pews at public auction and was built between 1808 and 1811 by John Tomson Jr., age 25. The town paid the minister until 1819, when New Hampshire passed the Toleration Act, which severed the connection between the town and the church. In this 1927 view, a Model T Ford is parked where horses, wagons, and carriages had gathered for over 100 years.

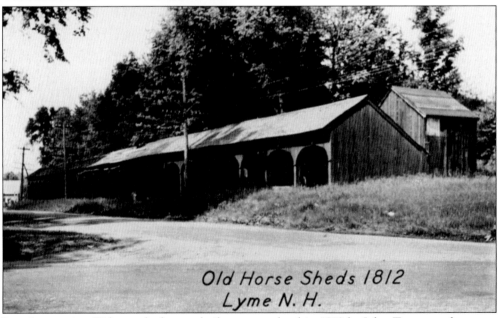

Old Horse Sheds 1812
Lyme N. H.

Lyme's surviving 27 horse sheds were built on town land in 1812 by John Tomson, whose son built the Lyme Congregational Church. They were sold to individuals, who did not own the land under their sheds. Owners could use them whenever they came into town. Originally there were about 50, and this postcard shows a boarded-up shed of another string of about 12. In addition, 10 "white" horse sheds ran parallel to Dorchester Road on the east side of the Brick School.

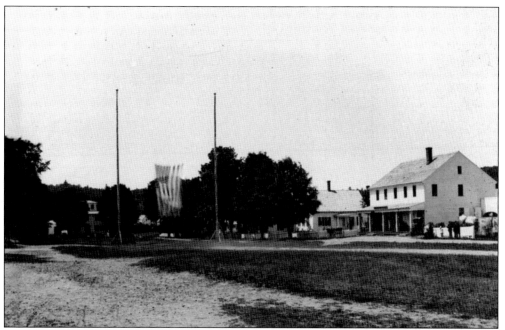

Looking northwest from the back side of the common probably around 1895, one of two sets of flagpoles on the west end of the common can be seen. One belonged to Republicans and one to Democrats. Horses and buggies, ladies with parasols, and men in suits and hats linger near the store (and town hall), which was owned by Leander Warren from 1890 to 1904.

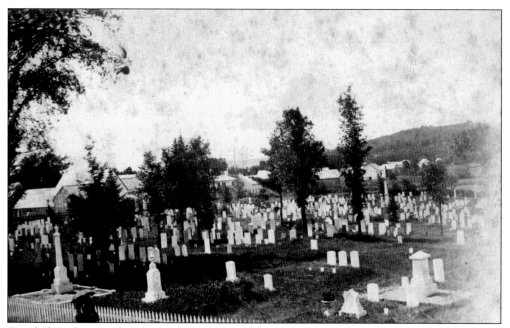

Two ladies sharing the shade of an umbrella stroll on Pleasant Street in front of the Old Cemetery, which dates from 1786. The flagpoles in the photograph above are just visible in the background.

This old house on the common is pictured here in the Victorian period, disguising its classic Colonial lines. Jonathan Conant, a Revolutionary War veteran, bought this property in 1785 but sold it to his nephew, the merchant Arthur Latham, in 1793. It is not clear which one built the house. From 1863 to 1869, it was owned by Dr. Abraham Dickey, who was famous for drowning in Lake Fairlee in 1882, and then in succession by D. C. Churchill and Henry Holt. Holt's daughter ran the Silver Lining guesthouse in the early 1900s, and it remains a bed and breakfast today.

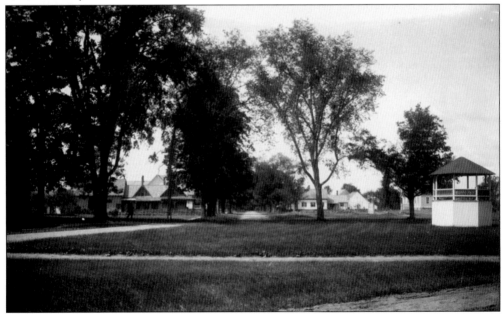

This view from around 1912 looks south down Union Street (the name of Dartmouth College Highway as it enters the village). The octagonal bandstand was a prominent feature from 1892 to 1926. The red school, barely visible on the right, was struck by lightning in 1911 but was immediately rebuilt almost exactly the same. About 24 years later, the Converse Free Library would occupy empty land to the left.

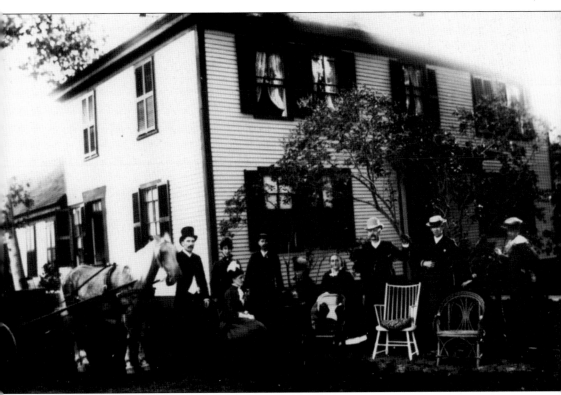

No. 2 on the Lyme Common, on the corner of Union Street and the back side, was built by Alanson Grant between 1802 and 1812. The original building was a cape-style dwelling that later became just a wing. The house was sold to Asa Shaw in 1823. This photograph, with seated dog and two empty chairs, could date from Thomas Shaw's ownership of the house, 1861–1885. In 1885, the house was inherited by John Kent.

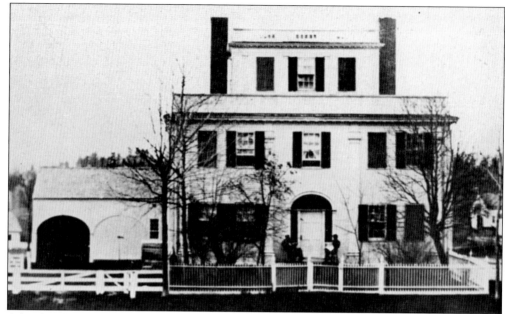

A landmark on the common since 1812, Lyme's most imposing mansion was built by Dr. Cyrus Hamilton, who came to Lyme in 1795. He built it in two stages—a small ell in 1802 and the large house in 1812—despite a devastating fire during the construction. This 1863 picture shows the builder's son Irenus (left) and Alfred Kitteridge dressed warmly and appearing to be reading on the front porch.

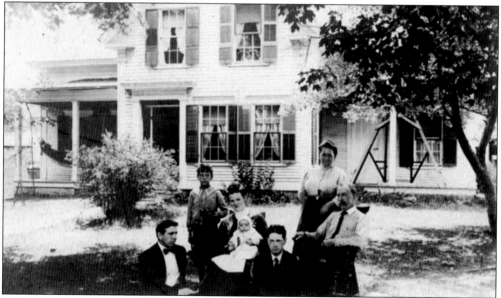

Another house little changed in appearance on the back side of the common was the home of the Claflins for many years. The first Claflins came to Lyme in 1800, and a descendant was an early introducer of merino sheep in 1844. In this July 1908 picture, P. H.A. Claflin and his wife, Eva (both far right), sit with family members in their front yard. P. H. A. Claflin became postmaster in 1889 but continued his tailoring business; repaired all kinds of machines, clocks, bicycles; and wrote most of the Lyme section for the 1886 *Grafton County Gazetteer*.

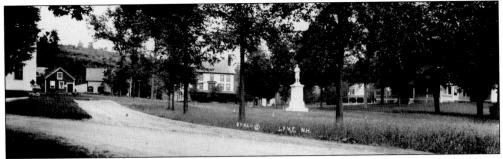

This view shows the common around 1920, after the Civil War memorial statue arrived in 1917 and the Grant Hotel was renamed Alden House. It looks east, with a telephone pole in the distance. The small building to the right of the church was Walter Piper's former coffin and harness shop, moved in 1917 to that site and soon to become a telephone switchboard—although Lyme had had some telephone service since 1890. The signs at left say "Danger, Go Slow," and also point to the Lake Tarleton Club, a very grand establishment at that time—but not located near Lyme.

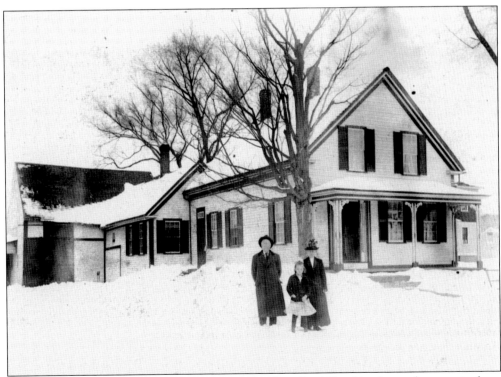

Harry O. Franklin; his wife, Lizzie; and granddaughter Pearl Franklin brave the snow in front of their Union Street house, next to the Lyme Plain School just visible to the right. When Franklin died at the age of 99 in 1932, he was Lyme's last Civil War veteran.

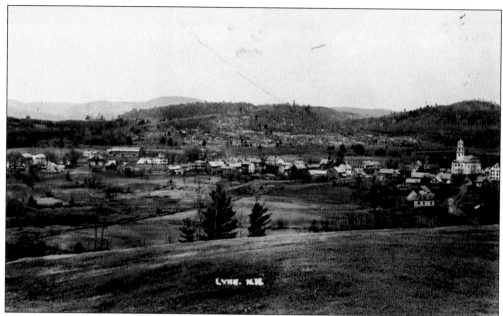

This view of Lyme in the early 1900s looks north from a hill south of Grant Brook, with Market Street clearly visible on the right. Although the landscape is open, the once-numerous sheep are gone.

Looking in a south-southeast direction from fields belonging to the old Lambert house on East Thetford Road (at the sharp bend), elms dominate the mostly cleared fields around 1910.

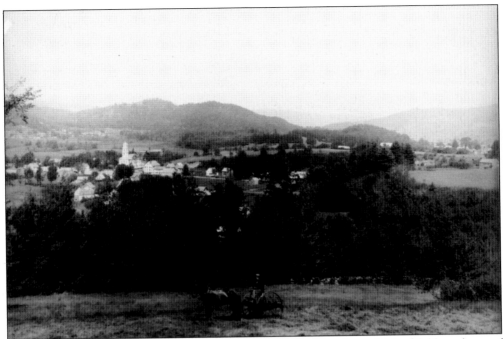

This view dating before 1914 looks north to Lyme. A farmer works on his hay field southeast of the village, with Dorchester Road in the distance.

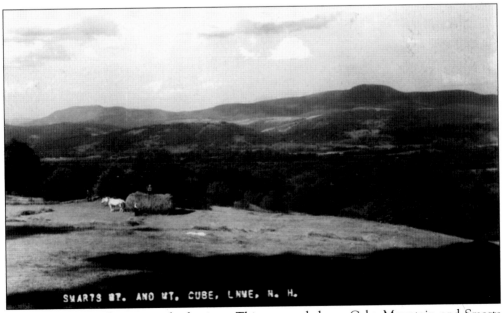

SMARTS MT. AND MT. CUBE, LNME, N. H.

Smarts Mountain dominates the horizon. This postcard shows Cube Mountain and Smarts Mountain in "Lnme," where men are pitching the hay.

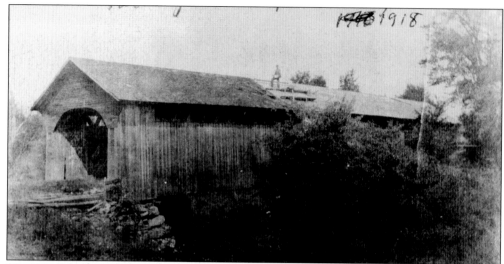

The Edgell Bridge, spanning the mouth of Clay Brook, was framed on the Lyme Common by John C. Piper and his son Walter G. in 1886 and dragged in sections by oxen to the River Road site. The town paid them $1,825. An inscription on this 1918 photograph refers to "Grampa" (Frank A.) Chesley, a lumberman, who appears to be giving the bridge a new roof. A tavern operated near the bridge from 1771 to 1886, and the building was torn down in the early 1940s.

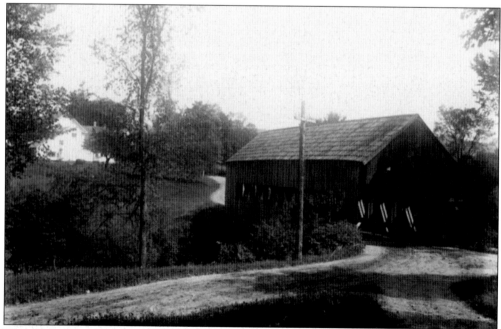

This covered bridge was on Grant Brook south of town on the Dartmouth College Highway (Route 10). From after the Civil War until the early 1900s, a blacksmith shop was adjacent to it, evolving into an automobile repair garage in the 1920s and 1930s. As the road was straightened and paved, these buildings and the bridge were demolished.

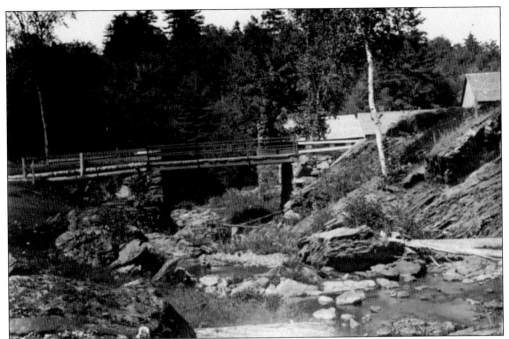

Farther south on the Dartmouth College Highway, the road crosses Hewes Brook, which was named after one of the first settlers in Lyme. This shows the old bridge, with a Hewes house in the background.

An unidentified man stands on a log in Trout Brook under the old "high bridge" on High Bridge Road while a woman watches from above. This bridge was destroyed in a 1927 flood.

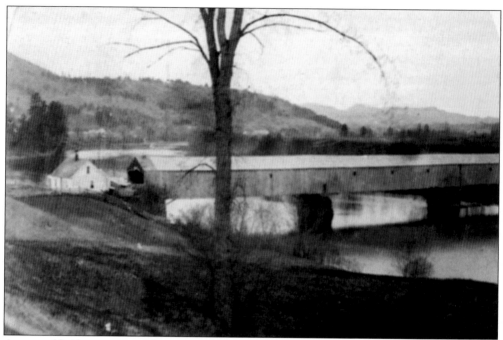

A covered bridge connected Lyme with East Thetford before it and the North Thetford covered bridge were destroyed by high water and ice on March 2, 1896, following a severe southeasterly storm. The replacement bridge to East Thetford did not survive the 1936 flood.

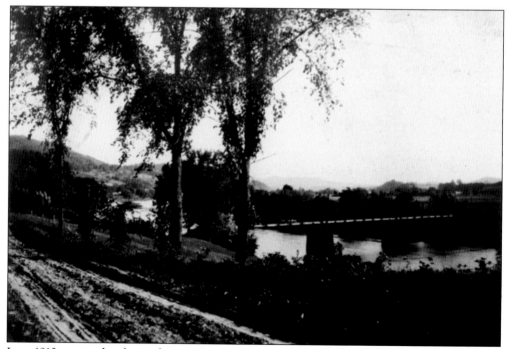

In a 1910 postcard, a horse-drawn wagon crosses the North Thetford Bridge, with a muddy River Road in the foreground. The bridge was damaged in the 1936 flood but remained in use, eventually as a footbridge, before being demolished by the state.

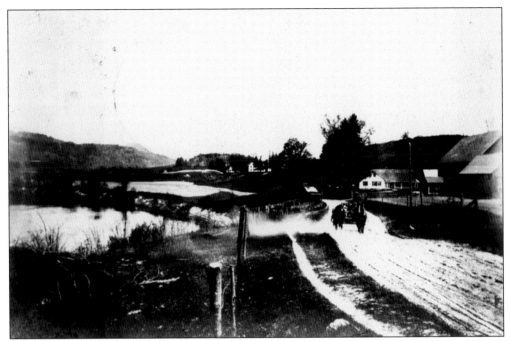

A horse team and wagon make their way south on River Road, between Gregory and North Thetford Roads. The wagon has just passed the sheep farm acquired by Isaac and Emma Holt in 1838.

It looks like early spring in this 1909 picture looking north up River Road from East Thetford Road. The distant house was originally the Three Beavers Tavern, built in 1776 by Capt. John Tomson as part of his Tomson Plantation.

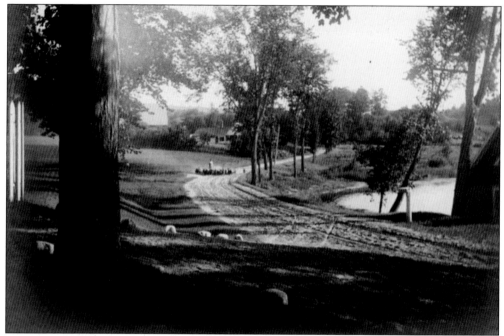

A farmer moves a flock of sheep along unpaved Orford Road past the farmhouse on Post Pond that became the Loch Lyme Lodge. The Thayers, who owned Camp Pinnacle, opened the lodge in 1923 for campers' parents and other visitors to Lyme.

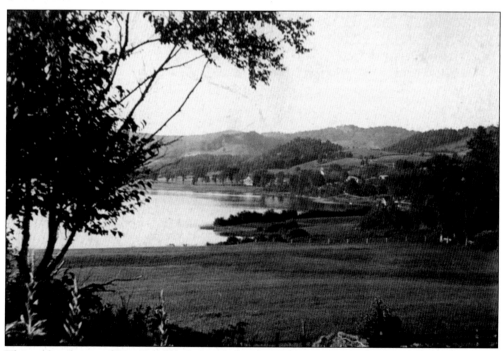

This undated view of Post Pond looks north from a pasture owned by West Balch. West was the son of Samuel West Balch, a tanner and drover, who built a home on Pleasant Street in 1850. The dwelling is still there.

A handsome elm shades the Orford Road, and chickens scratch around in the foreground.

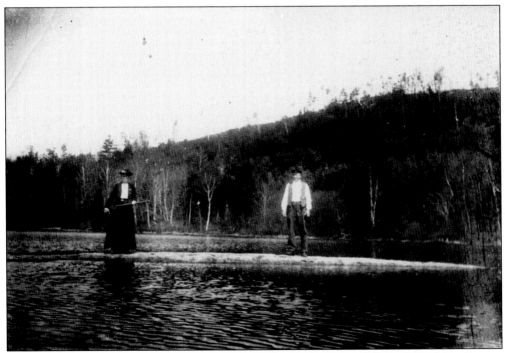

In what looks like 1890s garb, a formally dressed lady stands purposefully with a rifle or shotgun on a low rock in Pout Pond. What is she doing? Should the man be alarmed?

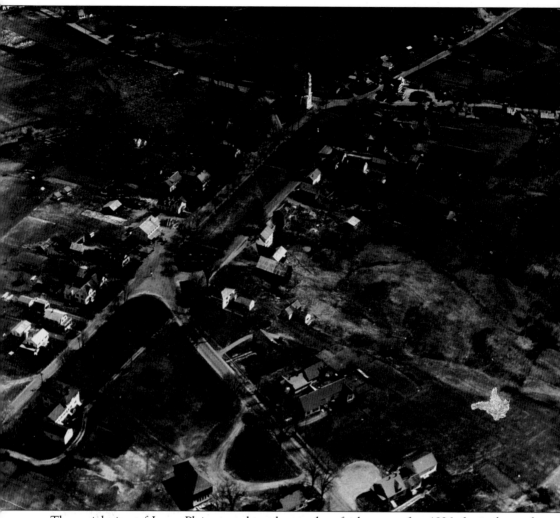

The aerial view of Lyme Plain must have been taken fairly soon after 1936, for it shows the Converse Free Library on Union Street that was completed that year with funds donated by Sidney Converse. A small traffic pole sits in the middle of the intersection of Union Street and East Thetford Road.

Two

PEOPLE AND HOMES

John Nelson, a Civil War veteran, poses with his dog on the Lyme Common. He held the Boston Post Cane (given to a town's oldest citizen) from 1913 until his death in 1928 at the age of 104.

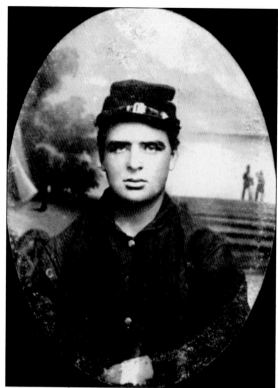

Harry Franklin, shown here in Civil War uniform, was the father of Foster Franklin, who operated the Franklin Farm on River Road and Grant Brook. The elder Franklin drove his own team of oxen in logging operations out of Lyme Center.

Clarence "Cad" Pushee lived on Pinnacle Hill. He was reputed to be a prankster at school in the early 1900s. Here, in a suit with medals on the lapel, he appears dressed for a serious occasion.

Anna M. Webster was a housekeeper for the Lamberts of East Thetford Road. Webster, here in a photograph by Hattie Wise, was noticeable around Lyme because she dressed in traditional Victorian clothing, always with a hat, well into the 20th century.

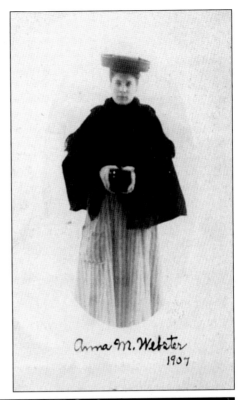

Anna M. Webster
1907

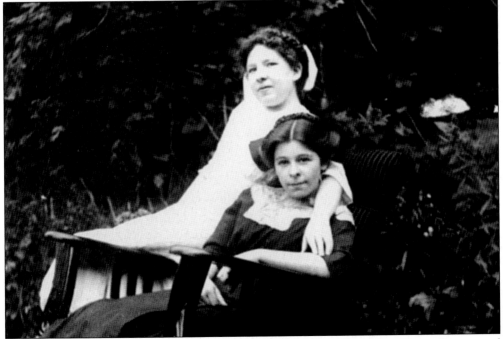

Lucy King (left) poses with her friend Mabel Cowan, daughter of Rev. John Cowan. King served as the Lyme telephone operator for more than 30 years and was very active in town affairs. She was a founding member of the Lyme Historians and a charter member of the Utility Club.

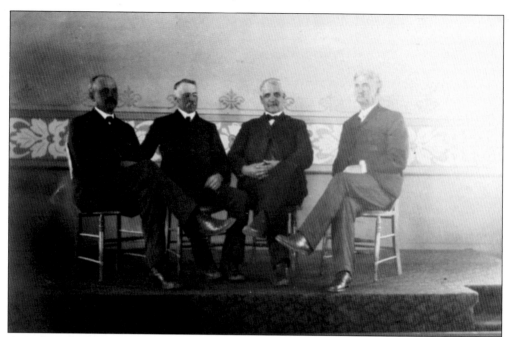

Attending the Managers' Lyme Lecture Course in the winter of 1906–1907 were (left to right) Dr. George Weymouth, longtime town doctor for Lyme; Roland Morrison, instrumental in creating a public library in 1907; George Melvin, proprietor of the general store; and Arad Warren, owner of the Perkins Hotel in the 1890s.

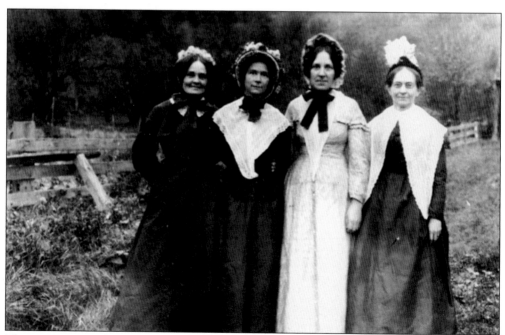

These women are, from left to right, Annie Andrews, wife of Earl Andrews; Pearl LaMott, wife of James LaMott; Agnes Pushee, wife of George Pushee; and Daisy Sanborn. They appear to be dressed for a special occasion.

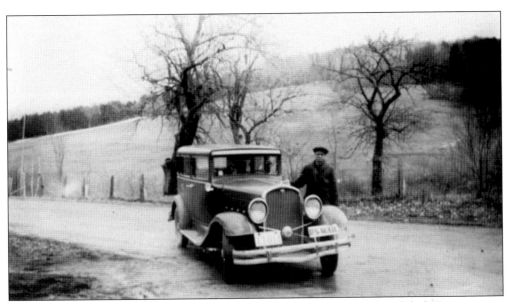

Lee Cutting, shown here in March 1936, delivered the mail with this automobile for many years.

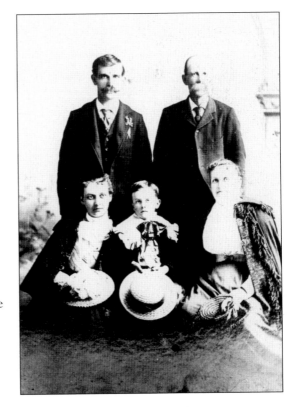

Ralph Balch (center, front) is shown here with his stepbrother Frank Balch (back, left) and his father West Balch (back, right). Seated in front are Harriet Balch (left), who was Frank's wife, and Julia Balch (right), the wife of West. Harriet and Julia were also sisters.

John Latham was a son of Robert Latham and a grandson of Arthur Latham, who was one of the early settlers of Lyme. Robert built and ran the Latham Tavern in the north end of town. John, perhaps a bit of a renegade and definitely a burly man known to be a hard worker, labored on farms around Lyme, notably on island property in the center of the Connecticut River, just north of the Hanover town line. Workers had to swim to the island and John, reputed to have webbed feet, was among the best of swimmers.

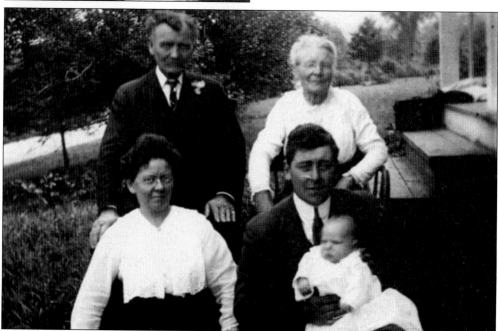

Four generations are shown in this photograph. Lilla and Edd Cutting (back row) were the parents of Bertha LaMott (front left), the wife of Albert LaMott. Bertha is seated beside her son, Elwin, and her grandson Paul. Paul, the older brother of Dean, grew up to serve many years as a representative in the New Hampshire legislature.

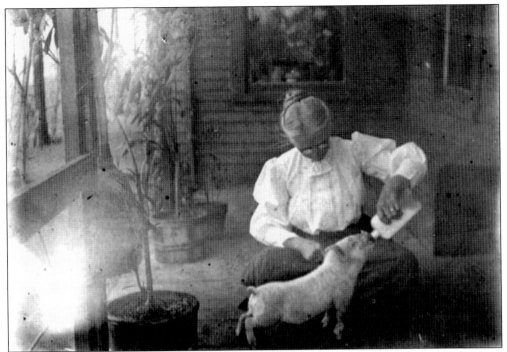

This charming postcard is addressed to Pauline Whittemore, June 12, 1911. "Here he is, Pauline. Isn't he a funny little fellow? His name is 'Piggie-Wig.' Lovingly your friend, Mrs. Harwood."

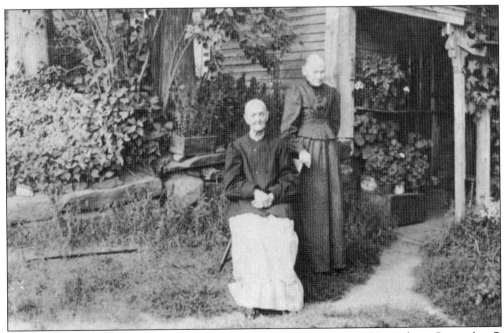

This postcard was addressed to Diantha Flint of Lyme Center, New Hampshire, September 7, 1907. "All well here as usual. Gertie is here. She carried Mother out to the old home yesterday and stopped and made a visit at Mr. Johnson's mother. Had a nice time done her lots of good. She had not been out to the old place for a long time." It was sent by Hannah Newell.

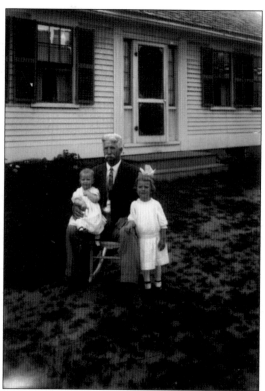

This photograph shows Roland Morrison posing with his grandchildren. Morrison's wife, Lizzie, was Lyme's first public librarian, from 1909 to 1920. In 1911, the library, located in the new red school on the Lyme Plain, burned and everything was destroyed, except the checked-out books. The school was quickly rebuilt, and the library occupied the upper room.

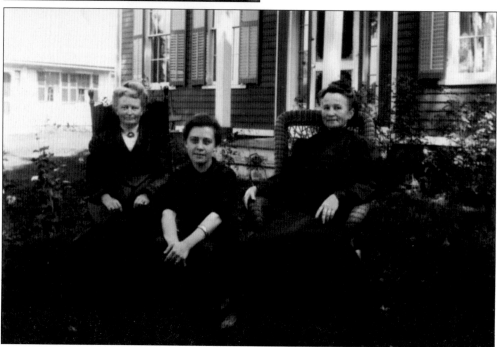

Three women sit out on a late summer's day in front of the Piper home at the east end of East Thetford Road, near the common. Two of the women are identified as Mrs. Adna Chase (left?) and Jennie Piper (in the center).

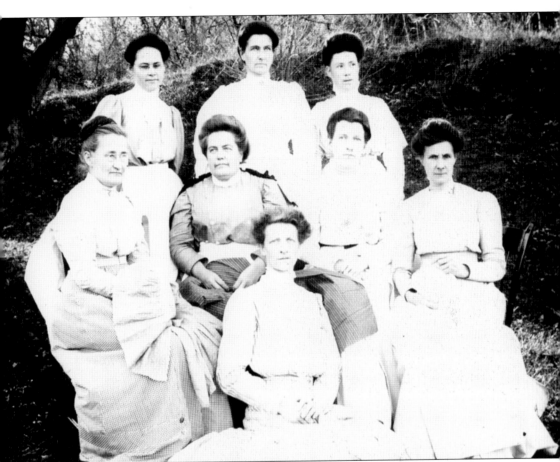

These women were members and friends of the Hewes family. Perhaps they were gathered for a family reunion. Pictured are, from left to right, (first row) Emma Aldrich; (second row) Mrs. Cummings, Mrs. Fred Warren (who lived on Shoestrap Road), Mrs. Fred Hewes, and Mrs. Arthur Rogers; (third row) Addie Hewes (who lived on Union Street), Mrs. Bert Hewes, and Florence (Clark) Hanchett. The Hanchetts ran a farm on Dartmouth College Highway from 1913 to 1942. Aldrich lived on Union Street. She occasionally took in boarders and called her establishment the Dew Drop Inn. Teachers at the Barnes School across the way would sometimes rent a room there.

These members of the Pushee family pose for a group portrait. George A. Pushee served as a selectman from 1901 to 1909 and again from 1917 to 1947.

In this gathering of Washburns and Whittemores, the first three on the left are Luther Whittemore, his wife Carrie, and their young son Albert. Carrie's father, Allen Washburn, is third from left in the back row, and others are unidentified. The Washburns came to Lyme in the late 1700s and, like the Whittemores, were direct descendants of the Sloans, Lyme's first settlers. Many generations of the two families lived at Maple Grove Farm on Washburn Hill Road.

Dr. Abraham Dickey (1820–1882) moved to Lyme in 1840 to practice medicine and dentistry. After 30 years, he moved to Massachusetts, but often visited Lyme. On one such occasion in September 1882, he accompanied the town's current doctor, John Marshall (below), to West Fairlee to consult on a patient. Conjecture abounds, but no one knows exactly why their carriage went into Lake Fairlee, drowning both men.

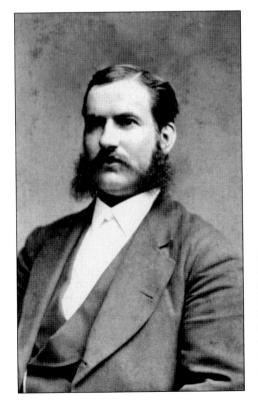

Soon after graduating from Dartmouth Medical School in 1871, Dr. John C. Marshall started practicing in Lyme, where he married Kate Perkins. He was also Lyme's school superintendent for many years. The 1886 *Grafton County Gazetteer* said, "no one applied in vain for his aid, and whether able to pay or not, received the best attention he could render." Dr. Marshall was 35 at the time of his tragic drowning with Dr. Dickey.

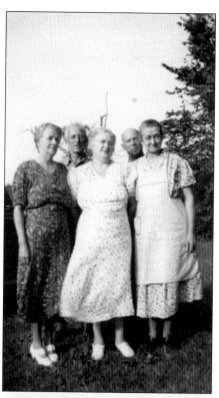

Perhaps these friends have just enjoyed a Sunday dinner. Shown here, from left to right, are Minnie Pushee, the wife of Gene Pushee, Walter and Ethel Horton, Frank Barnett (?), and Mary Coburn. The Pushees lived just south of the parsonage on Union Street.

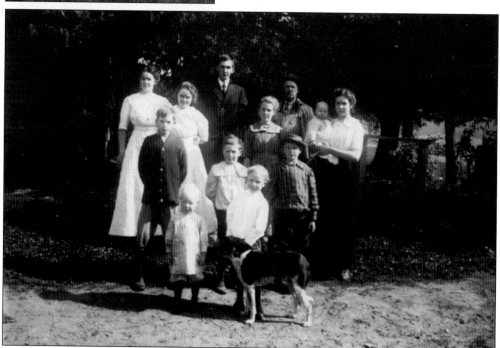

Adna Perkins is pictured here (back row, third from left) with some of his family. Adna was a sheep farmer who later delivered the mail in Lyme. He was the great-grandson of Isaac Perkins, one of the original settlers in Lyme Center.

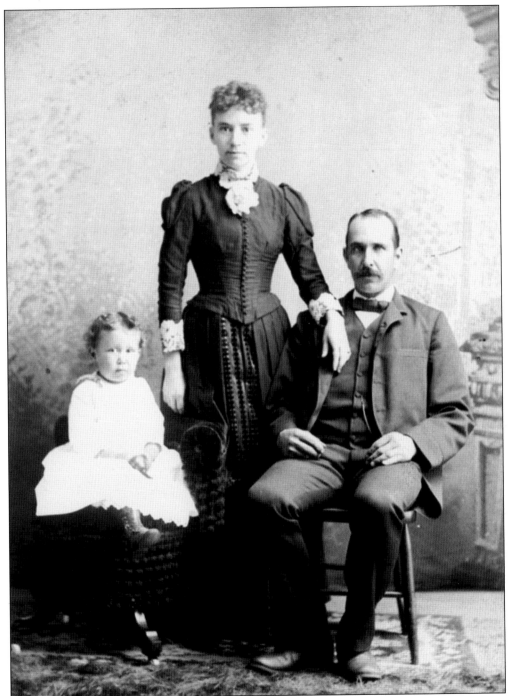

Theodore and Mary Wise lived with their daughter, Hattie, on North Thetford Road. Theodore was a farmer, and young Hattie grew up to become an accomplished amateur photographer and active town citizen (see page 8). The following four pictures were taken and labeled by Hattie.

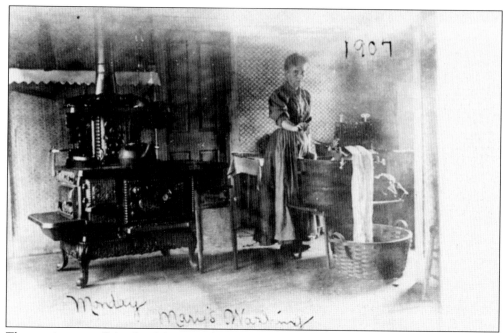

The caption says, "Monday, Mary's washing." Getting the laundry done was no small task in 1907, and the expression on Mary's face does not imply much delight in her work. The first electric washing machines were mass-produced in 1906, but it was unlikely there were many, if any, in Lyme at that time.

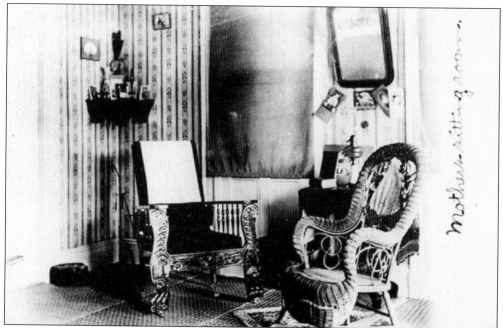

Shown in this photograph is "Martha's sitting room" at the Wise home. In 1907, someone may have been reading the new works of Upton Sinclair, Edith Wharton, or E. M. Forster on loan from the town library. L. M. Montgomery's *Anne of Green Gables* was published the following year.

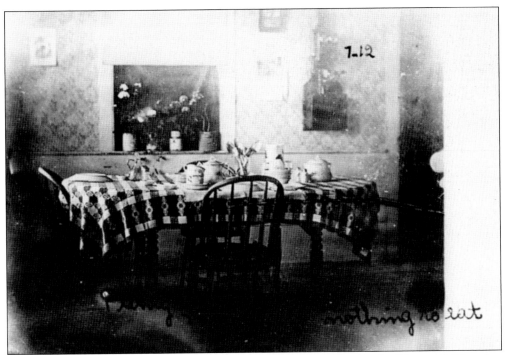

The Wise dining table is set for the next meal, and the wry caption reads, "Plenty of dishes, but nothing to eat."

Theodore Wise (right) enjoys a potation with Newton Goodell near the woodstove. The caption reads, "How dry I am." Goodell lived on Pinnacle Hill Road with his wife, Fanny, and daughter Dorothy, a close friend of Ruth Whittemore.

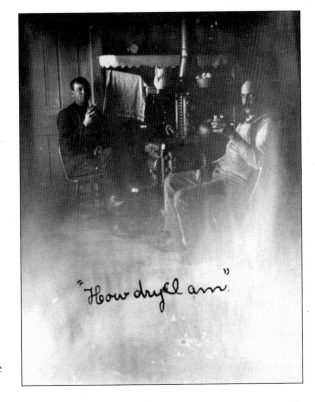

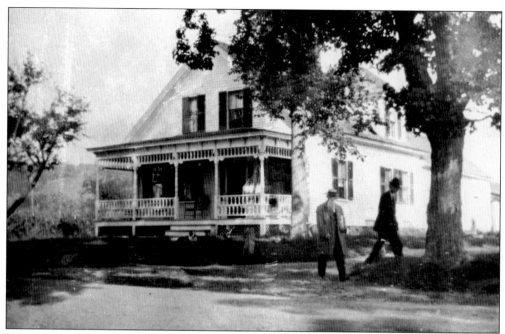

Two men, Payson Fairfield (left) and Earl Perkins, walk in front of Julia Mayo's house on Union Street. Mayo served as town librarian from 1920 to 1937. Fairfield was a former town clerk (1874–1878) and frequent school board member; Perkins was a tax collector from 1923 to 1941 and one of the 13 children of Adna Perkins.

This cottage, owned by the Badgers on the banks of Post Pond, was a year-round residence. Henry Badger was employed by the post office in Hanover, and his daughter Marion taught at the Pond School.

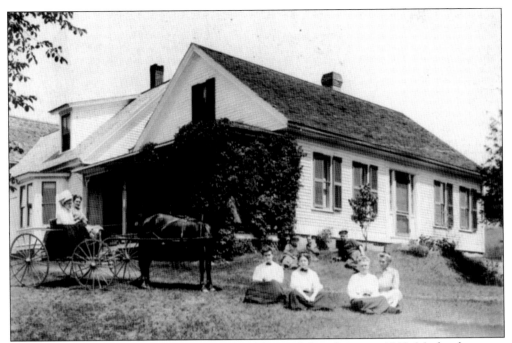

Members of the Turner family sit on the front lawn of their home in 1909. Maybe they were taking turns in the buggy. This house is located on the east side of Dartmouth College Highway on the southern outskirts of town.

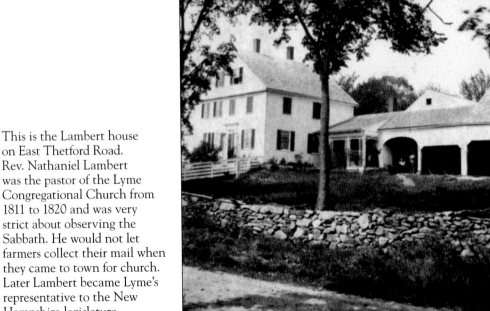

This is the Lambert house on East Thetford Road. Rev. Nathaniel Lambert was the pastor of the Lyme Congregational Church from 1811 to 1820 and was very strict about observing the Sabbath. He would not let farmers collect their mail when they came to town for church. Later Lambert became Lyme's representative to the New Hampshire legislature.

45

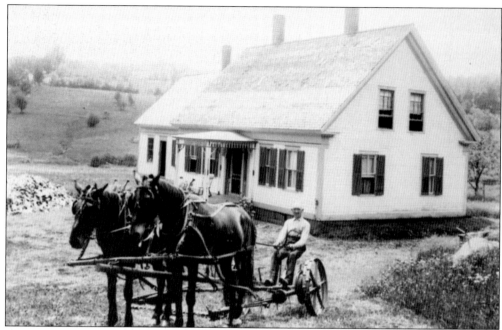

This house was located in Stark Hollow on Baker Hill at the tight curve near Hewes Brook. This farmer appears ready to do some mowing with his horses. Alongside and beyond this house, Goodell Road once ran, connecting to East Road. Both roads have since been abandoned, but did once provide a short route to Washburn and Preston Roads.

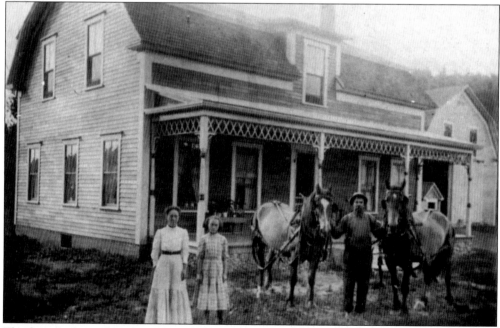

This home is located just west of the Lyme Center Baptist Church. The photograph shows Daisy Sanborn, wife of Charles Sanborn; Dora Taylor; and Charles Sanborn. Charles, who owned the sawmill across the road with his brother, Newton, built this house in 1910 after the previous structure burned. It is distinguished by a matching gambrel-roofed barn, connected by a gambrel wing.

This Whipple Hill home was the site of an infamous 1885 crime. Stephen R. Lamphere, a boarder at the home, shot and killed Mrs. Mark Donaldson after she had rebuffed his repeated romantic advances. Upon realizing what he had done, Lamphere shot himself in the heart.

The Edward Jenks House, also known as the Mill House on Brook Lane, was photographed in 1907. Duane Small's gristmill was located near here on Grant Brook. It burned in 1933, nine years after the Smalls' eldest son, Ralph, assumed ownership.

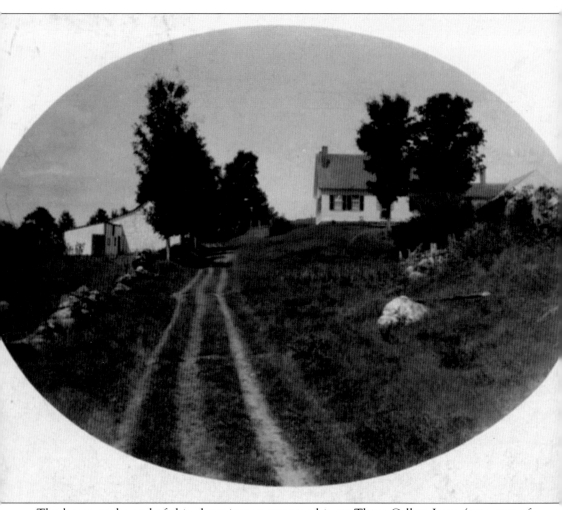

The house at the end of this charming country road is on Three Cellars Lane (now part of Pinnacle Hill Road), high on Pinnacle Hill. Since the countryside was largely cleared, the view to Post Pond and beyond must have been outstanding.

Three

LYME CENTER

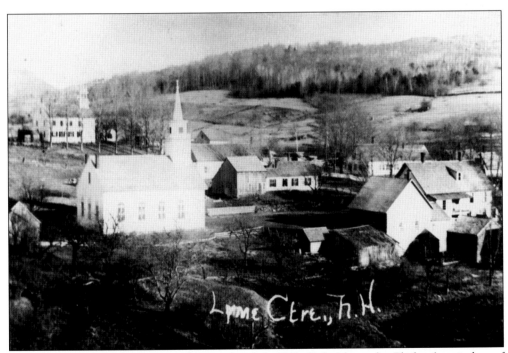

A few months before Lyme was chartered in July 1761, Col. Alexander Phelps (son-in-law of Rev. Eleazer Wheelock) sold lot 43, which was 100 acres, to a John Cook. John also bought lots 40 and 44. These 300 acres are where Lyme Center stands today. In 1783, Maj. James Cook arrived to clear a building site, followed by several of his brothers. James had 14 children, and the village was called Cook City for many years. This picture was taken before 1910 from a hill behind the village.

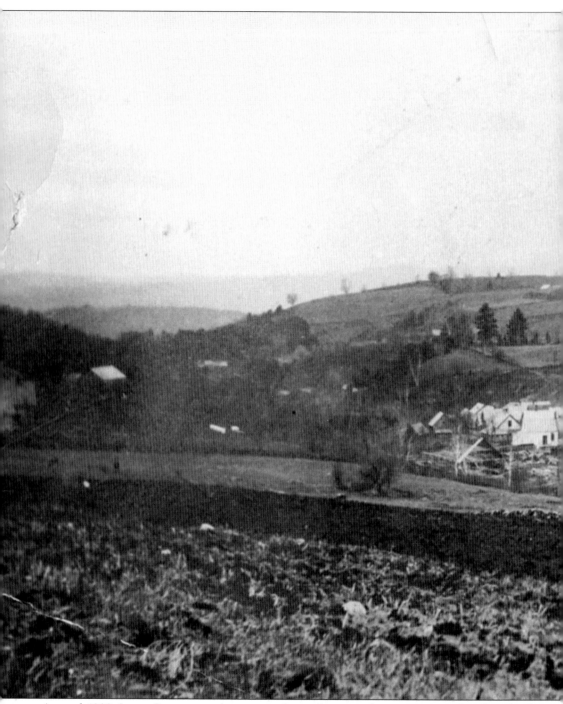

Around 1900, Lyme Center was the center of area farms, with two stores, a church, school, slaughterhouse, and blacksmith. A steam lumber mill on Grant Brook was the third on that site. This photograph shows the lumberyard in the center at the Baker Hill intersection and also the

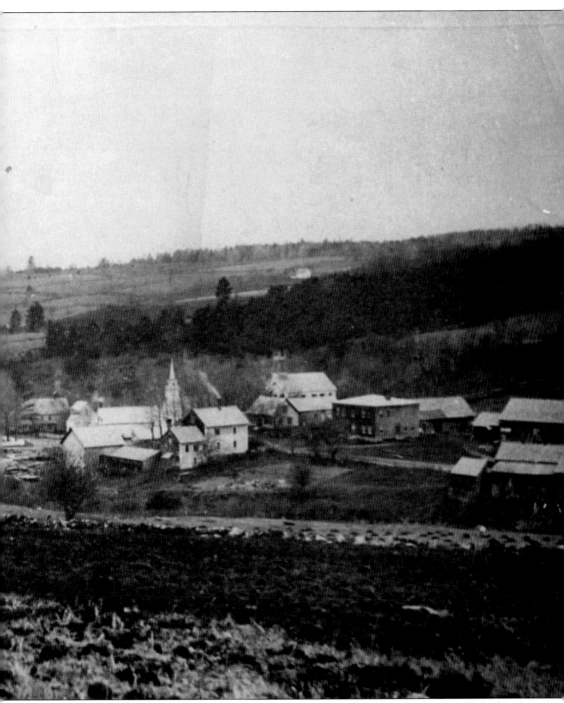

50-foot-square Cook Hotel (to the right of the Academy) with the distinctive roof. The hotel housed mill workers and visitors from 1812 to 1905, when it burned.

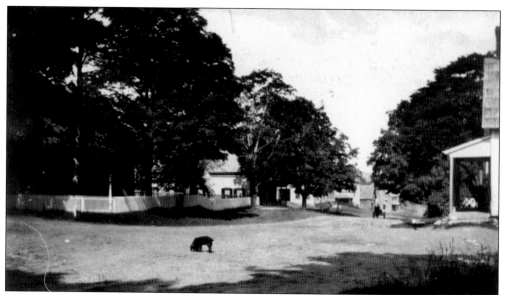

This postcard, mailed in 1908, shows a dog sniffing something interesting in the Baker Hill-Dorchester intersection, ignoring an approaching horse and wagon.

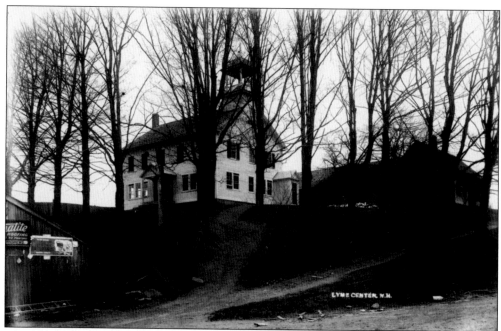

The Lyme Center Academy was built in 1839, financed by a private corporation, not the town. Electricity was installed in 1936 and running water soon thereafter. When Lyme consolidated the schools in 1959, the academy was closed but reopened in 1965 to house the town's kindergarten program for many years. Then, as now, dances and social events were held at the academy. A corner of the horse sheds, seen in the lower left, that accommodated customers of the store or other Lyme Center businesses, is just visible, as is the Fred Palmer house in the upper right. The house was eventually removed, and the town bought the land from the Palmer estate in 1938 for a school playground.

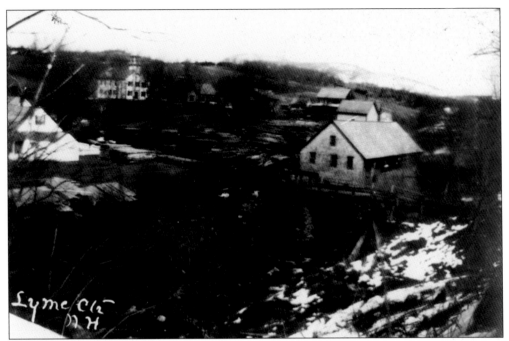

Looking at the town from the south side of Grant Brook, the melting snow shows the extent of the Sanborn mill on Grant Brook. Lumber is stacked from the brook to Dorchester Road and on both sides of Baker Hill Road.

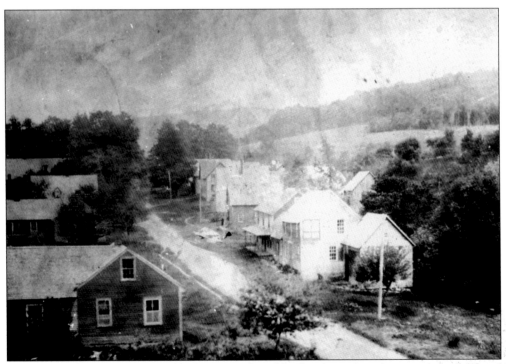

Looking east up Dorchester Road before 1909, the "old yellow house" can be seen in the left-hand corner. It burned in 1909, killing its occupants, Mr. and Mrs. William Aldrich.

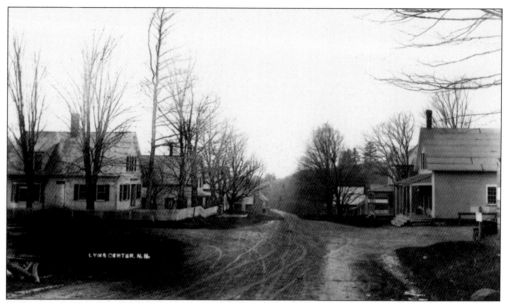

The intersection of Dorchester Road and Baker Hill, looking west toward Lyme Plain, shows the 1840 M. K. Webster house on the southwest corner facing the store across the street. This Lyme Center store was built in 1876, immediately after the original 1826 one burned. Ownership changed fairly often. Edwin B. "Win" Palmer, who grew up in the house next to the Lyme Center Academy, owned the store in this photograph. There is a hitching rail alongside the store, but a car is peeking out at the far right, showing that times are about to change.

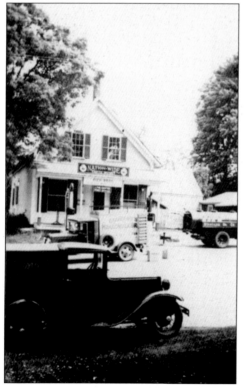

This photograph shows that times have definitely changed; gas pumps have arrived, and the horse sheds have departed. In 1923, the Rich Brothers General Store was purchased by Roger and Everett Rich, who operated it until the early 1970s. The building also housed the Lyme Center Post Office.

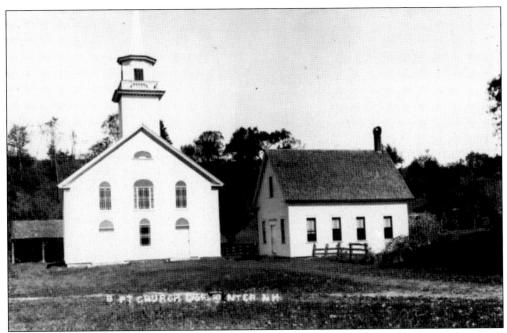

The First Baptist Church was first organized in 1807, and this church was built in 1830, which was the same year that Lyme's population peaked. The vestry building on the right came along in 1895. The horse sheds behind the church were torn down in 1929.

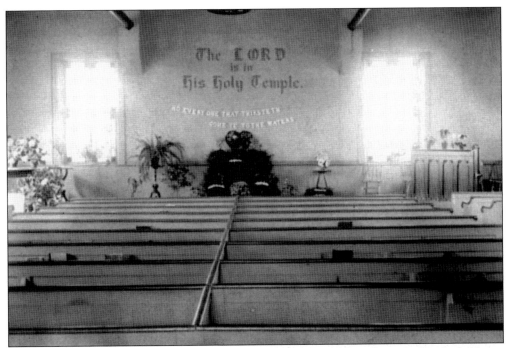

This shows the interior of the Baptist church before the woodstove (see overhead pipes) was replaced by an oil furnace in 1972. The windows of rolled colored glass date from 1905, and in the early 1920s, the interior was repainted in pastels. In the mid-1950s, the church was redecorated.

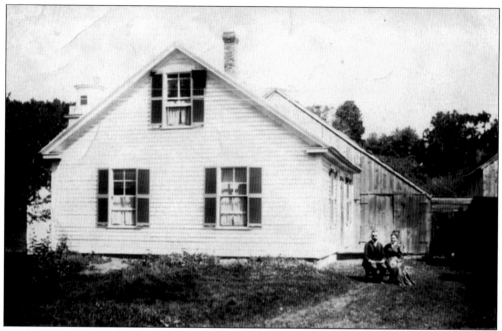

Rev. and Mrs. Bertrand Webster, posing here, were the last to live in the original Baptist church parsonage, built in 1833 with attached barn on land adjacent to the church. Webster served as pastor from 1900 to 1911, when the parsonage was sold to the general store proprietor, Edwin B. "Win" Palmer, who moved it up the hill to the site of the former Cook Hotel.

In 1912, the Baptist Church built this new parsonage basically on the site of the old one, immediately east of the church. Much of the labor and materials was contributed by the Sanborn family, who owned the lumber mill in Lyme Center, and by others. The church sold the parsonage in 1973.

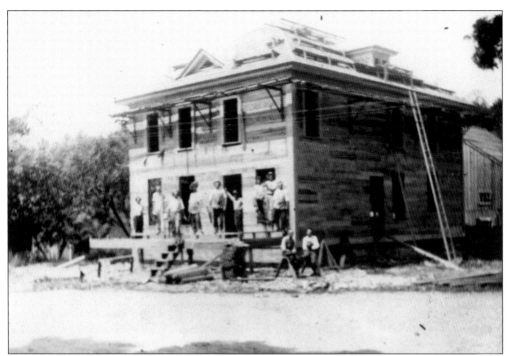

Not all of those working on the new parsonage (above) are identified in the lower photograph, but they included Fred ?, Walter Piper, James LaMott, Warren Shattuck, Earl Perkins, and Allie Piper.

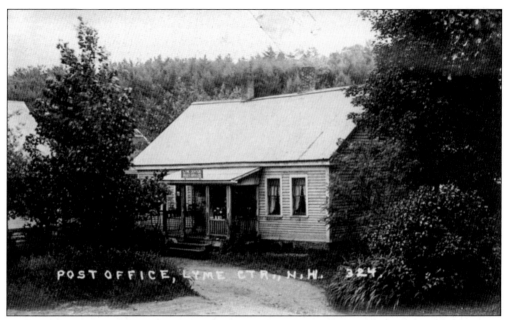

POST OFFICE, LYME CTR., N.H. 324

One of the oldest remaining houses in Lyme Center (the second house west of the Baptist church) was built in 1826 and served as the post office for the village for some years in the early 1900s. The owner, Anna Flint, was the postmistress. The mail stage made two trips per day to East Thetford. For most of the village's history, however, the post office has resided in the general store, the building now owned by the Rich Insurance Agency.

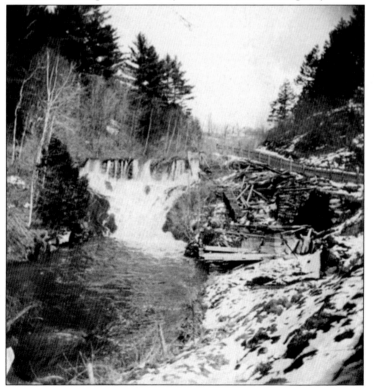

Mills and factories on Grant Brook played a large role in Lyme Center's past. Three buildings succeeded each other on the falls between Lyme Plain and Lyme Center. Samuel West Balch built the first tannery here in 1846. It was rebuilt after a flood in 1869 under a new owner, W. A. Bingham. In 1901, the operation was sold to Warren Shattuck, who manufactured shingles for a while. In this picture, it lies in ruins.

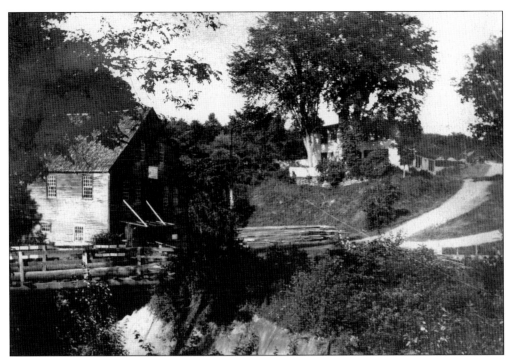

Originally a fulling mill built by Jonathan Franklin in 1795, this factory on Grant Brook at the intersection of Franklin Hill and Dorchester Road had a succession of owners and purposes, turning out chairs and ladders by the 1880s, and ox yokes in the early 1900s.

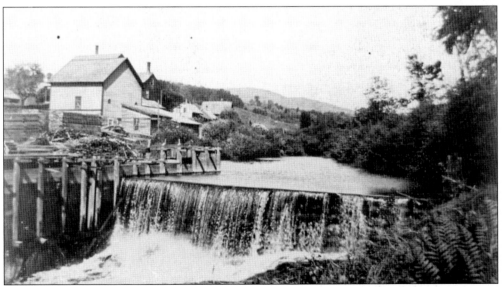

Three lumber mills succeeded each other on Grant Brook in Lyme Center village, but the first two burned. The Sanborn family owned the last one from 1876 until it ceased operating in the late 1930s, after Newton Sanborn died. Before it closed it had been a sawmill, gristmill, and cider mill. Most logs, often stored in the pond, were sawed in the spring when rain and snowmelt increased the water flow and power. Less power was needed to make clapboards, shingles, or laths. In 1948, Roger Rich built a house on the mill site.

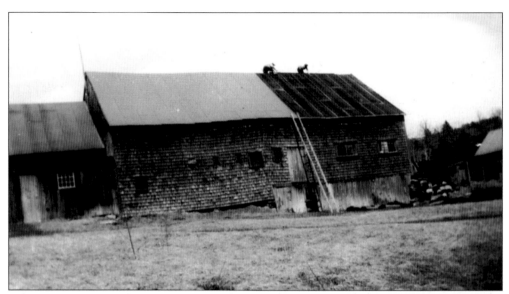

In the upper picture, carpenters work on the roof of the huge Dimick barn just east of the Lyme Center Academy. In the lower picture, taken around 1951, the largest part of the barn has just been demolished. The house to the left was built in 1924 by Ed Dimick on the site of the old Baptist parsonage and, earlier, the Cook Hotel. Dimick ordered the house from Sears, Roebuck and Company in 1924, paying $2,473. He assembled it and finished it with custom lumber from the Sanborn mill.

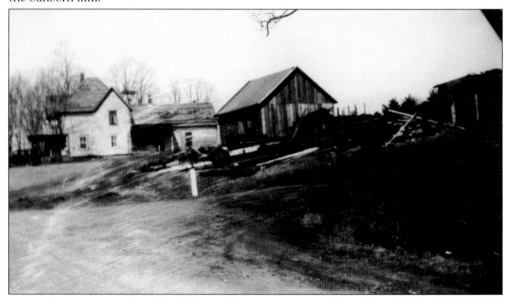

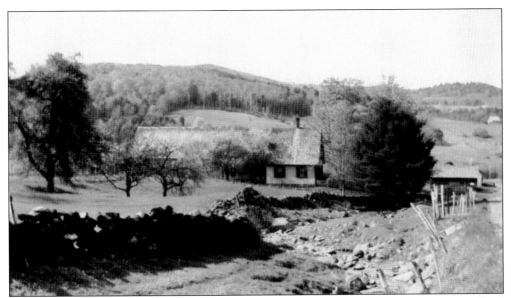

Looking south on Acorn Hill toward Dorchester Road, the open countryside shows an orchard above Gracie Cutting's house at the time of this undated picture. In 1870, Freeman Holt owned the house.

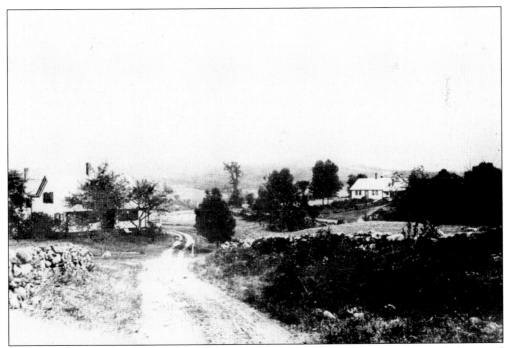

This old but undated photograph was taken near the northern junction of Isaac Perkins and Baker Hill Roads, looking up Isaac Perkins Road. The path of the road seems to have changed quite a bit over the last century.

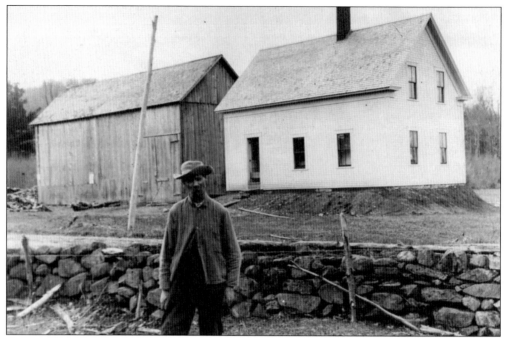

George Woodward's attitude conveys the hard work of a hill farmer. He stands in front of his house near the intersection of Baker Hill and Goose Pond Roads. His stonewall is in good repair, supplemented with barbed wire.

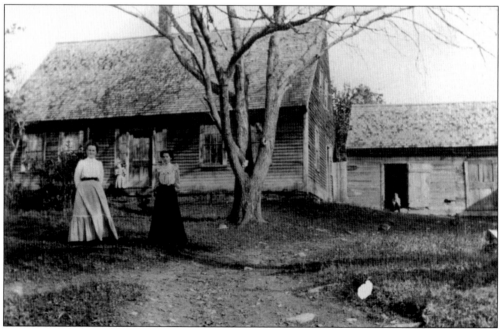

Mrs. Edd Webb, standing on the right, enjoys the early spring sun in front of her house on Baker Hill just before the intersection of Claflin Lane and Pico Road. She was born Clyde Hanchett in 1880, and she and her twin brother composed an entire class when they entered the Hewes School in 1887.

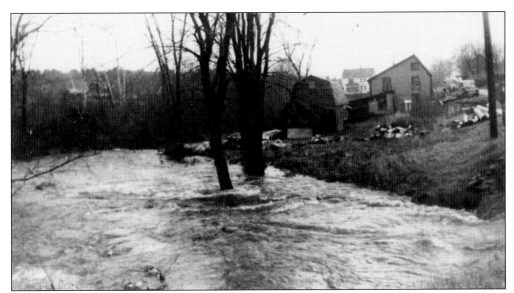

A raging Grant Brook, perhaps during the flood of 1936, threatens the Lee Cutting house just across from the intersection of Dorchester Road and Acorn Hill.

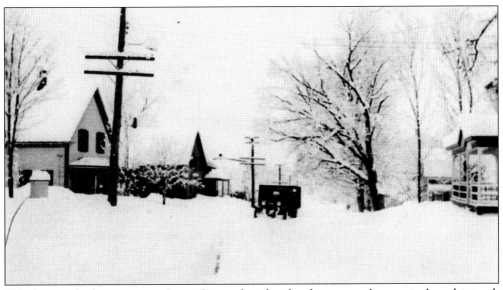

Telephone poles have come to Lyme Center, but the plow has not, at least not when this truck was trying to push uphill through the drifts of a spring snowstorm near the village center on April 13, 1933.

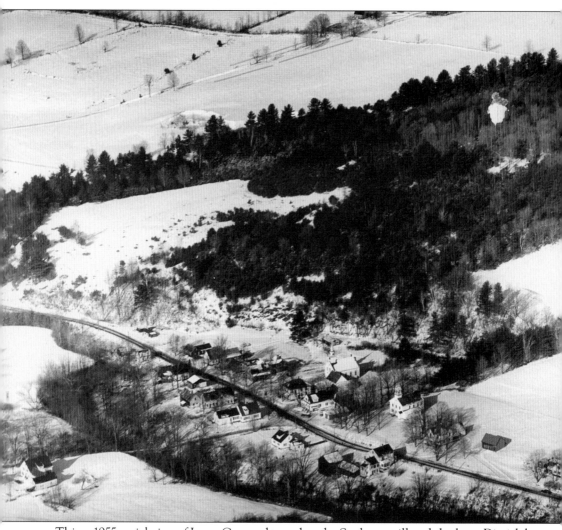

This c. 1955 aerial view of Lyme Center shows that the Sanborn mill and the large Dimick barn no longer exist. Only 50 years ago, the countryside was still more open than today.

Four

CHILDHOOD

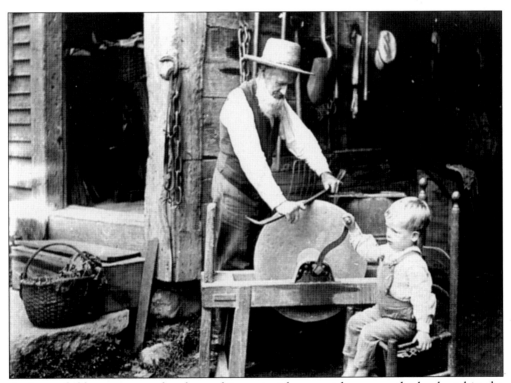

As Lyme children grew up, they learned important lessons at home, on the land, and in the schools. Here Albert Whittemore helps his grandfather, Allen Washburn, sharpen tools at Maple Grove, the family farm. It is harder to turn the grinding wheel than this picture would suggest, but children were often taken along while their elders worked. In a few years, young Albert probably had his own chores to do each day.

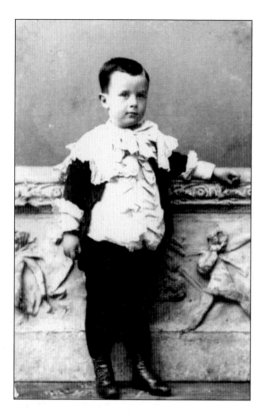

Ralph W. Balch was born in Lyme in 1894. Although this early portrait shows him in ruffles and bows, by the time he was in grammar school (below) he was clearly dressing for future success as a leader in town.

Ralph served 50 years as a library trustee and as town moderator from 1929 to 1966. The Balch family still lives in the homestead built by Samuel West Balch in 1850 on Pleasant Street.

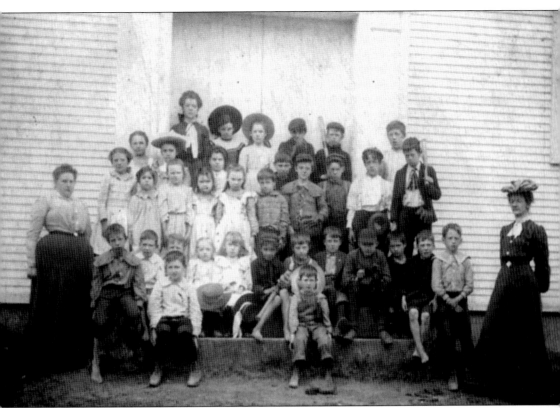

Pupils of the Brick School line up on the steps of the Lyme Congregational Church in 1904. Their teachers, standing on each side, were Jennie Blood on the left and Miss Tuck on the right. Some of the barefoot boys have bats and gloves with them and look eager to get the picture over with so they could play ball on the common. From left to right are (seated in the first row) Harold Wilson, Harold Covey, Lee Warren, Raymond Claflin, Helen House, Merle House, Harry Uline, Allie Piper, Ralph Balch, Ralph Lamphere, Jesse Gilbert, Hazel Turner, Hazen Claflin, and Earl Bryan; (second row) Sadie Wilson, Lauline Wilson, Vera Warren, Mary Uline, ? Hosmer, Ila Mosely, Bessie Gilbert, Emily Mosely, Roswell Mativia, Leslie Elliott, Gus Brockway, James Bond, Melrose Claflin, Newton Dike, and Ben Dike; (third row) Ethel Turner, Mildred Willey, Gladys Claflin, Lee Piper, and Dean Perkins.

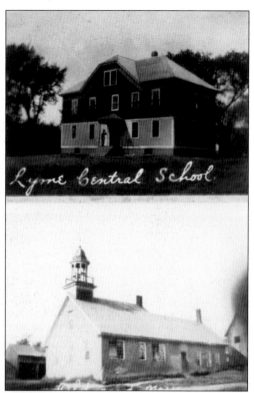

Lyme Central School.

This postcard shows the old Brick School (lower picture), built in 1835, and the new school on Lyme Plain built in 1906. Children living near the center of town, in District No. 1, attended these schools. Many one-room schoolhouses served all the outlying areas of town.

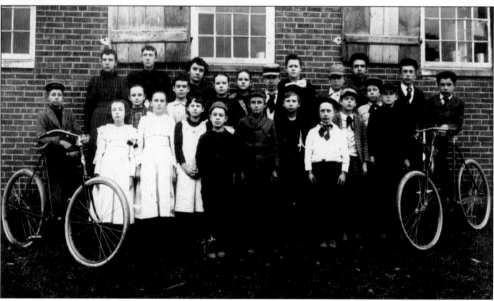

Another year, another group of students at the Brick School. From left to right are (first row) Dustin Brackett with his bike, Jennie Converse, Nellie Mativia, Maud Piper, Harold Carlton, Hiram Uline Jr., Earl Perkins, Chester Haley, Frank Cory, Edwin Gordon, and Leon Melvin with his bike; (second row) Mildred Grant, Mabel Skinner, Anna Fairfield, John Frost, Theodore Gordon, P. Leon Claflin, Gordon Haley, Cynthia Wilson, Sara Holt, Rose Gilkey (teacher), Marion Fairfield, Augusta Dike, and Foster Franklin.

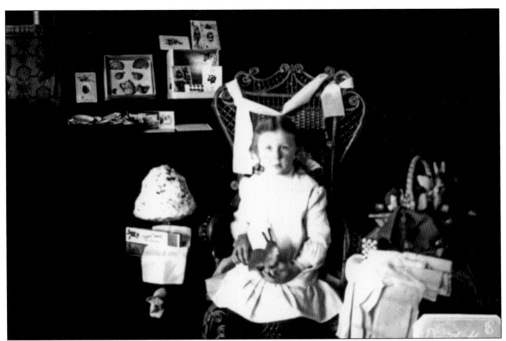

Dorothy Henry was raised by Ila and Sidney Converse in the brick house across from the Lyme Creamery. This picture shows Dorothy with all of her birthday gifts displayed on the piano in the parlor. Her birthday cake is on a cake stand to her right.

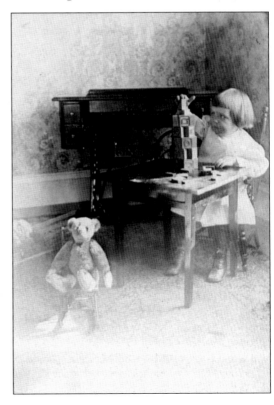

W. Francis Chase lived in the large yellow house at the intersection of Orford Road and North Thetford Road. He seems very intent on a building project in front of his mother's Singer sewing machine. The jointed teddy bear seems more relaxed.

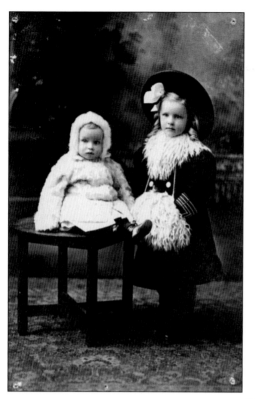

In 1911, Leon and Florence Melvin lived with their daughters, Thelma and Theda, across the common from the church. Their grandfather, George, ran the general store from 1891 to 1906. Their father was a brakeman on the railroad that ran from White River Junction to Sherbrooke, Canada. He might have bought these fur outfits on one of his trips to Canada.

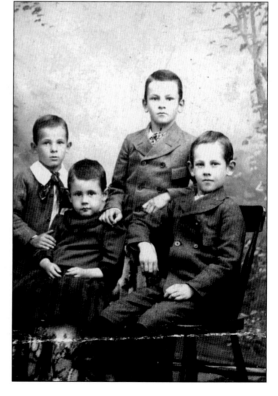

The four Piper boys were, from left to right, Bennie, Frank, Herbert, and Willie. They were the sons of the family that operated several sawmills in town. Their father and grandfather built the Edgell Bridge and the huge Norris barn on River Road. They also built the Lyme Plain School and rebuilt it after it was struck by lightning in 1911.

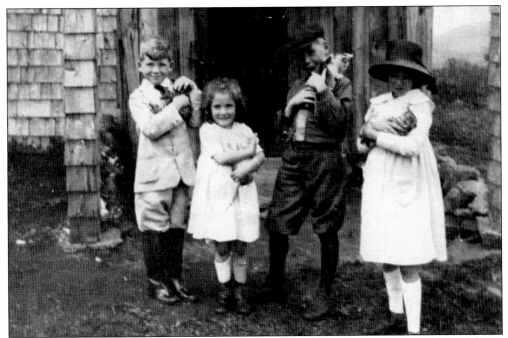

Every farm had at least one barn cat to keep the mice from the grain. Inevitably, kittens appeared every year. From left to right, dressed in their Sunday best, Billy, Janet, and Joe Kendall share their kittens with their friend Frances Hann.

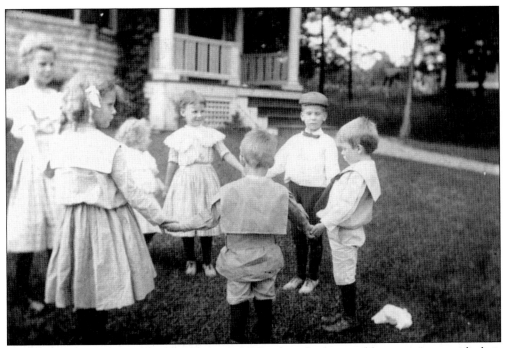

The children of Lucian and Amy Whittemore Woodworth play an old nursery game with their friends: "A tisket, a tasket, a green and yellow basket, I wrote a letter to my love and on the way I dropped it."

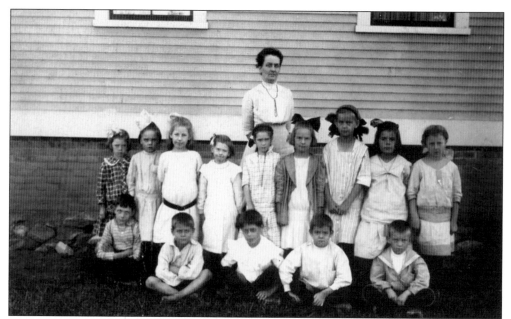

This photograph shows Hattie Warren with her students at the Lyme Plain School around 1916. Pictured in the first row are, from left to right, Ralph Hewes, Millard Uline, Charles Webb, Ira Small, and Grant Balch. In the second row are Mabel Brockway, Pearl Franklin, Pauline Whittemore, Gladys DeWitt, Vera Bryan, Thelma Melvin, Esther Small, Edith Watson and Dorothy Henry. Large hair bows seemed to be in style.

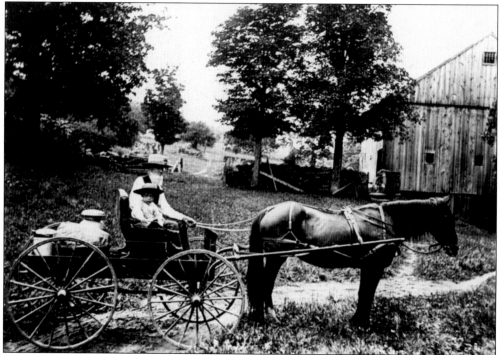

After milking the cows, Alfred Whittemore rides along with his grandfather into town for supplies and to bring the milk to the Lyme Creamery.

Pearl Dimick was born in 1893 at the family farm on Hardscrabble Road. Her parents later moved to Lyme Center and built a Sears, Roebuck–designed house next to the Academy building. Pearl attended Bryant and Stratton Business College in Manchester and served as town clerk for 31 years and town treasurer for 34 years.

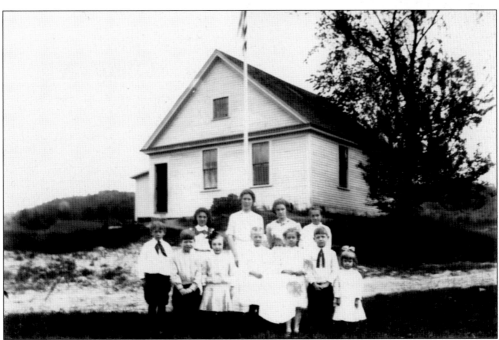

Mildred White was the teacher at the Pond School in 1914. Four of her ten students were from the Pushee family. The teachers in the one-room schoolhouses taught students of all ages in their neighborhood or district, covering every subject.

Roger (left) and Everett Rich, sons of John and Ida Rich, grew up on Baker Hill Road and attended the Lyme Center School. They became owners of the Rich Brothers General Store in Lyme Center. Roger was the Lyme Center postmaster from 1939 to 1971, and Everett served as town moderator from 1966 to 1978.

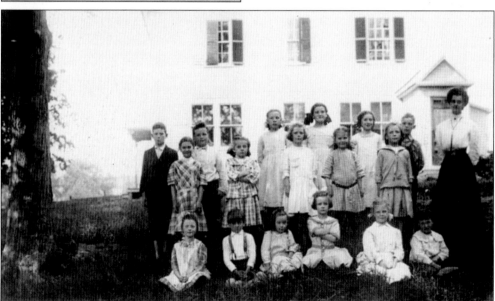

The Lyme Center Academy School was built in 1839. Around 1913, this picture was taken of Florence Flint with her students. Pictured in the first row are, from left to right, Lizzie Pike, Roy Balch, Mabel Dimick, Marjorie LaMott, Freda Smith, and unidentified. Included in the second row are Doris Jenks, Margaret Hubbard, Julia Pushee, and unidentified. In the third row, from left to right, are George Derby, Martin Camp, Ruth Dimick, Edith Farley, Maude Morrow, and unidentified.

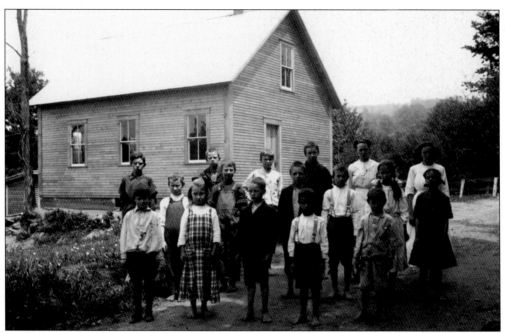

The Whipple Hill School, in District No. 9, was near the crossroads of Pinnacle and Orfordville Roads and was used from 1795 to 1944. Alice Hobart Cutting is shown with her students at the school. Among the barefoot children are Carl Simpson, Roy LaMott, Mary Webster, Elmer Rowell, and their various siblings. The privy can be seen to the far left.

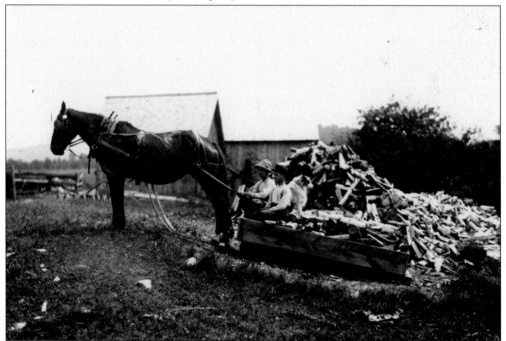

Arthur and George Bryant and their dog drive a sled loaded with firewood to the woodshed. This was a year-round job because wood was needed every day for the stove for cooking and for washing clothes by hand, not to mention the many cords needed every winter for heat.

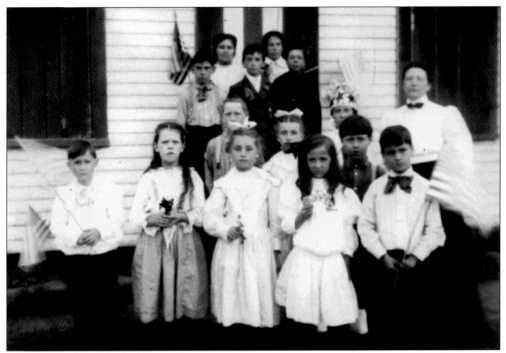

The Hewes School, located near the Hanover line in District No. 6, was open from 1794 to 1930. It was sometimes known as the Sodom School because the older boys were so disruptive. Ralph Hewes and his sister Ethel are the two children on the left in the first row. The flags suggest that the children were celebrating Memorial Day.

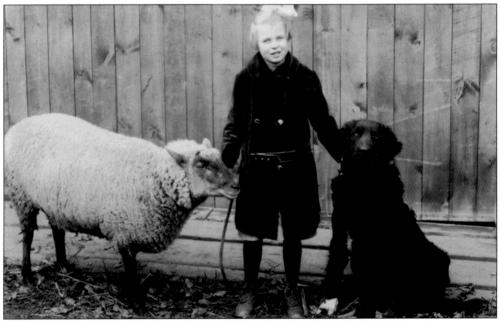

The Goodell family lived on Preston Road. Their daughter Dorothy has a firm grip separating her prize sheep and the family dog.

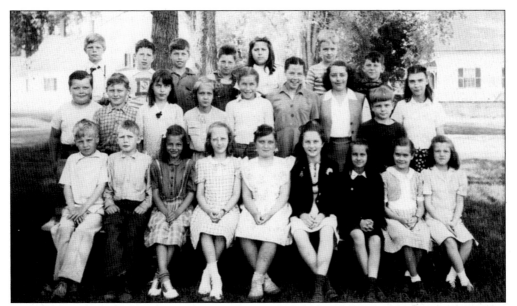

In 1945, the third and fourth grades at the Lyme Plain School were a combined class. Pictured in the first row are, from left to right, Frank Balch, Arthur Bundy, Carol Drew, Kay Gottschalle, Donna Record, Ruth Duke, Evelyn Small, Margaret Uline, and Nancy Chase. In the second row are Walter Record, Talbert Bacon, Barbara Drew, Inez Hutchins, Mildred Wilmot, Florence Wilmot, Miss Braley (the teacher), Kendrick Putnam, and Anne Granger. In the third row are Stanley Pushee, Richard Moulton, Kent Degoosh, Russell Wilmot, Lillian Wilmot, John Franklin, and David Durgin.

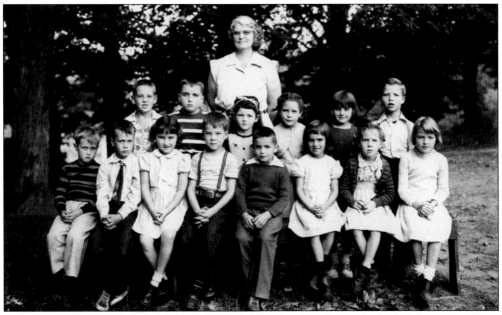

Margaret Young taught the primary grades in Lyme from 1931 to 1971. In the 1949–1950 school year, she taught a combined class of first and second graders at the Plain School. Pictured from left to right are (first row) Robert Sanborn, John Wing, Priscilla LaMott, Ralph Pike, Albert Cole, Wanita Balch, Mary Ann Movelle, and Mary Holt; (second row) Sammy Grey, Jackie Eastwick, Maxine Elder, Rose Marie Movelle, Sarah Balch, and Jerald Coburn.

Although not twins, Vera Warren and Marjorie Morrison are dressed almost alike for their graduation from the Lyme Plain School in 1907.

Program

INVOCATION · · · Rev. G. M. Woodwell

ESSAY—Our National Songs · · Robert H. Kemp

ESSAY—A Tribute to American Women Myrtle L. E. Thompson

RECITATION—The History of Our Flag—A. P. Putnam
Laurence F. Bailey

SONG · · · · Dorothy Henry

DRAMATIZED HISTORICAL EVENT—Nathan Hale
Lyme Plain Graduates, assisted by other pupils
 Act I. Time, 1775
 Place, New London, Conn.
 The Union Grammar School
 Act II. Time, 1776
 Place, American Camp. Washington's Headquarters

Program

Act III. Time, September 20
 Place, Long Island. The British Camp

Act IV. Time, The next morning, before sunrise
 Place, Room where Capt. Hale is confined

ESSAY—Getting an Education · J. Chellis Evans

ESSAY—A Story in Gum · · Gladys DeWitt

ESSAY—"Valedictory" · · Dorothy M. Goodell

SONG · · · Lyme Plain Grammar School

REMARKS BY THE SUPERINTENDENT · C. W. Cutts

PRESENTATION OF DIPLOMAS · Arthur E. Derby

SONG—America the Beautiful · · All Schools

This is the program of graduation from June 24, 1921. Despite combining all the eighth-grade students of four schools, only 11 students were graduating. Descendants of some of these students still reside in town in 2006.

Five

LIVELIHOOD

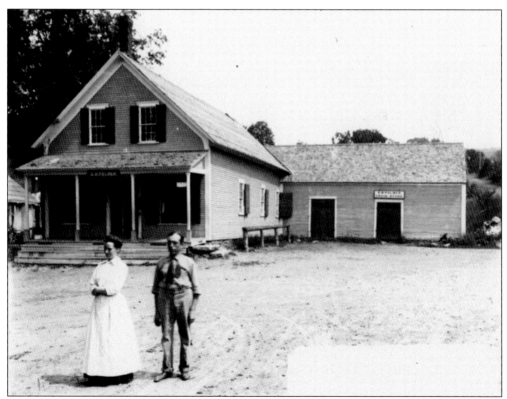

Edwin B. "Win" Palmer and his wife ran the Lyme Center Store on Dorchester Road from 1910 to 1923. They sold groceries and hardware, along with grain and feed in the back. The building was a general store until 1971.

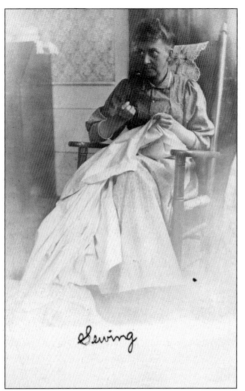

Sewing

Women conducted many of their traditional household duties indoors and, therefore, were not frequently photographed at work. Mary Wise is pictured in a photograph taken by her daughter, Hattie, while doing some sewing.

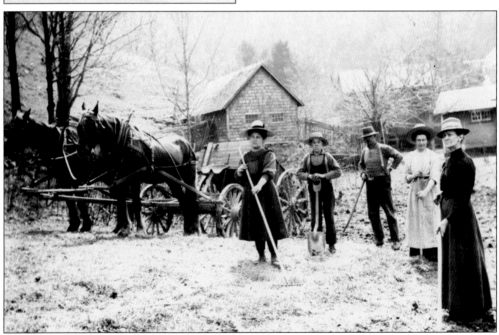

The family of Carroll Jewell pitches in to get some farm work done. Pictured are, from left to right, Ina, John, Carroll, Mrs. Jewell, and Rose Wilder. The house, once located at the junction of Shoestrap and River Roads, is no longer standing. John Jewell grew up to become a logger and, according to the *Hanover Gazette* in 1886, once brought in a spruce log that was 146 feet long.

These steers in yokes were used for hauling stone boats (to remove rocks from farm land) and other heavy farm equipment. Steers are young cattle; once they reach four years old they are called oxen and have been taught to work.

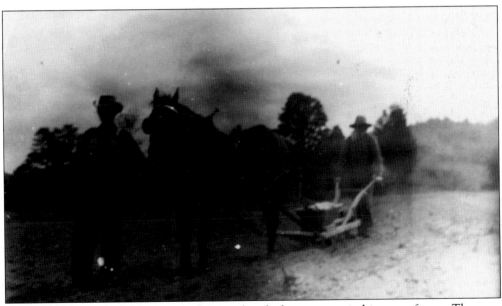

Theodore Wise used this ingenious farm tool and a horse to put in his crop of corn. The corn planter had plow handles and a small, V-shaped "plowlet" at its front to push the soil. A little bin with a spinning disk contained the corn kernels and dropped them at a rate determined by the farmer. At the same time a metal container dropped fertilizer. Finally, a small chain dragged a piece of cast metal to replace the soil and a wide metal wheel tamped the soil back down again.

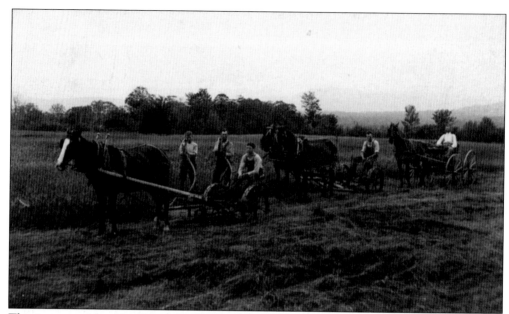

This is a postcard to Pearl Dimick of Lyme Center from August 8, 1910: "We are all most threw [sic] haying, suppose you are threw a long time ago hope to see you some time with best regards from A.N.E.N." The horses did most of the work in mowing, but drivers used care to avoid features in the land that might interfere with the process or damage the mower. Hand scythes were also used for cutting hay.

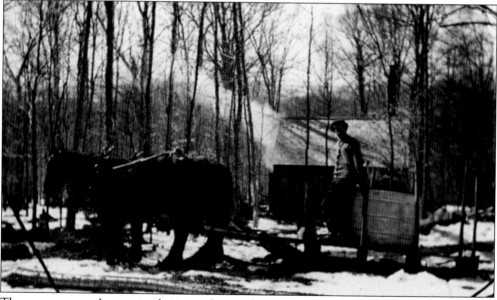

Then, as now, maple sugaring begins in Lyme when winter loses its grip. With warm days and cool nights, sap starts running from the maple trees. Pictured here, Ralph Small gathers sap in a wide barrel on Preston Road. The horses pull him on the sled so he can empty buckets of sap that are hung from the taps on individual trees into this barrel. Later the sap is boiled down to syrup in the sugarhouse, which is shown in background. The steam pouring out of the shed indicates the sap was running well on this particular day.

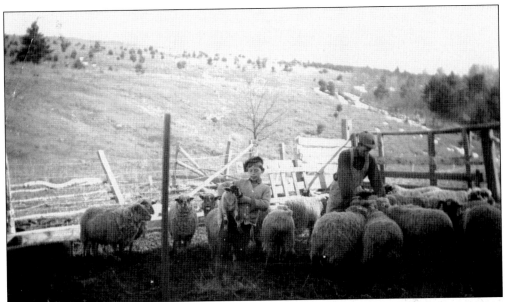

Young Albert Whittemore (left) helps his father, Luther, with sheep at Maple Grove Farm in the early 1900s. By the mid-19th century, the sheep population had soared above 13,000, making Lyme one of the largest wool-producing towns in New Hampshire. According to James Goldthwait's "A Town That Has Gone Downhill," Lyme farmers took pride in their pure merino stock. As the century wore on, the local sheep industry declined as farmers became disenchanted by disease, aggressive dogs, the expense and labor of repairing fences, and strong competition.

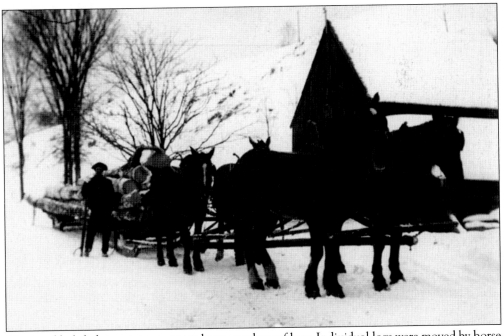

Men used bobsleds in winter to move large numbers of logs. Individual logs were moved by horse and chain. A bobsled was a short, wooden sled with a bunk made of 12-by-12-inch timber, to which a man could chain the logs.

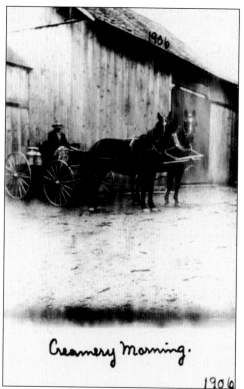

Creamery Morning.

1906

Lyme dairy farmers hauled their milk in 40-quart cans to the Lyme Creamery, a cooperative founded in 1888. Eventually tanker trucks picked up the milk at each individual farm.

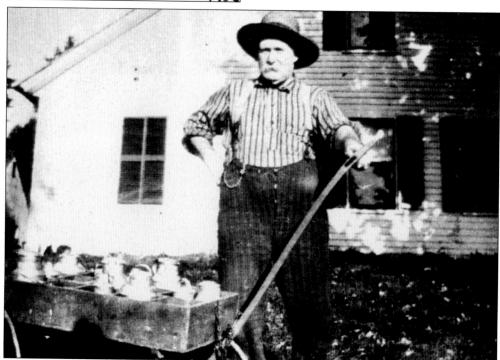

Several farms, such as the Record and Washburn dairy farms, delivered milk along routes around town. Carroll Fales poses with his wagon.

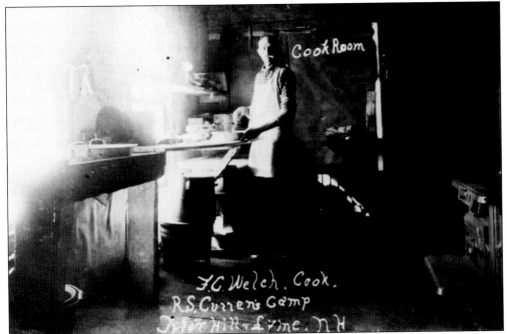

Fred Welch oversees the cook room at the Curren Camp on Tyler Hill, east of Holt's Ledge. One can only imagine the stacks of pancakes and gallons of maple syrup consumed at camps such as this.

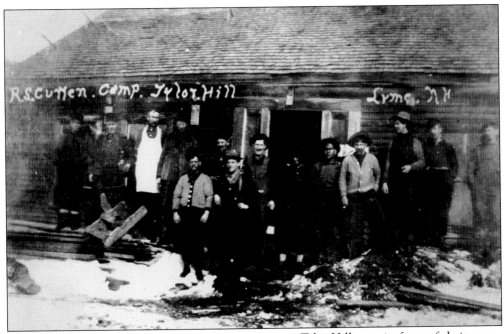

The workers at the R. S. Curren logging operation on Tyler Hill pose in front of their camp. Charles Dimick, who is probably the man with the moustache by the door, is among them. The crew at a logging camp usually included not only the cook but also a blacksmith, teamsters (to drive the horses or oxen), choppers, and men to work the sawmill.

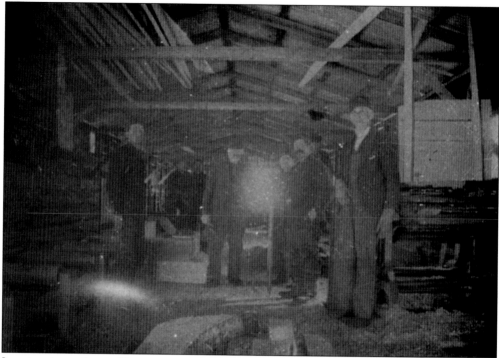

Interior views of sawmills were unusual. Here workers pose amid the sawdust.

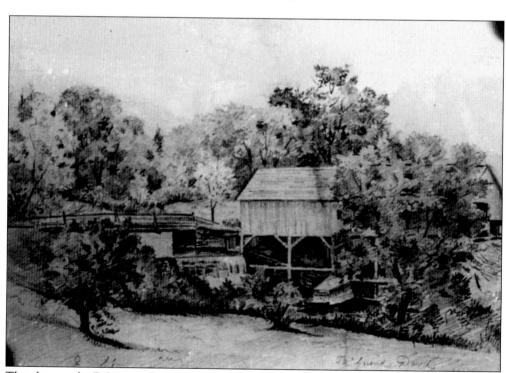

This drawing by E. Letang, dated August 1885, is of the Pushee sawmill located near Post Pond on North Thetford Road.

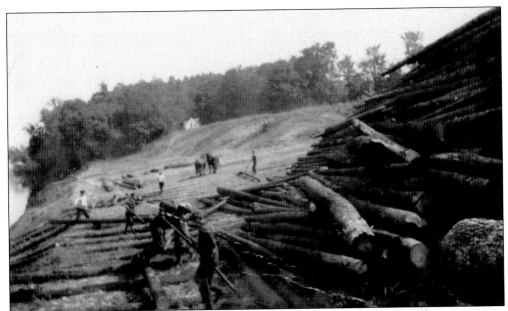

These logs, transported from eastern Lyme along Grant Brook in winter, were rolled into the Connecticut River after the spring thaw. The photograph dates from about 1910.

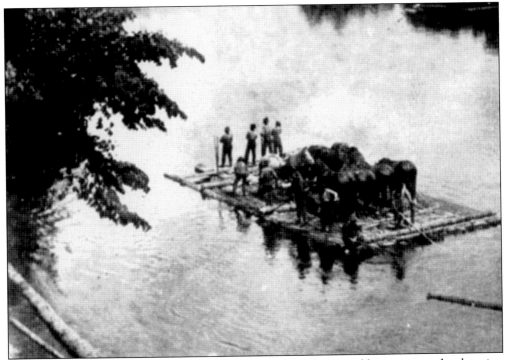

Several logs were lashed together to transport a number of men and horses to another location down the Connecticut River.

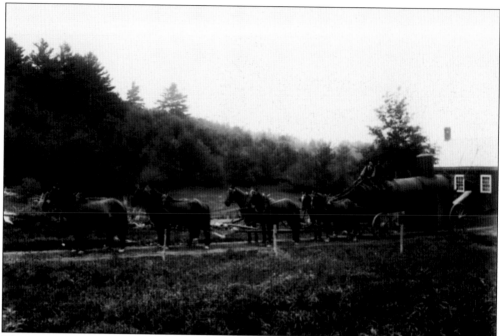

This wood-fired boiler used steam to power mills. Water for the steam was drawn from a nearby brook. The steam powered a piston engine, which turned the saw or other machinery. Walter Piper operated a portable boiler in the early 1900s. Moving the boiler from site to site could take up to a week. In this photograph, eight horses were required to move the heavy boiler.

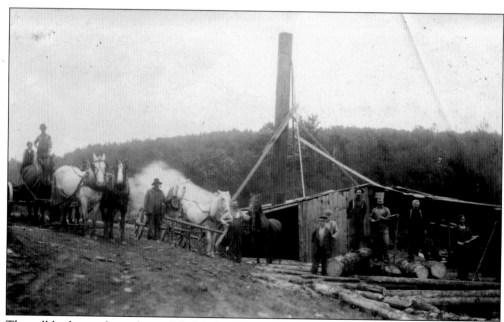

The tall boiler stack on this mill behind Levi White's house on Acorn Hill helped to prevent sparks from igniting the roof and causing a fire.

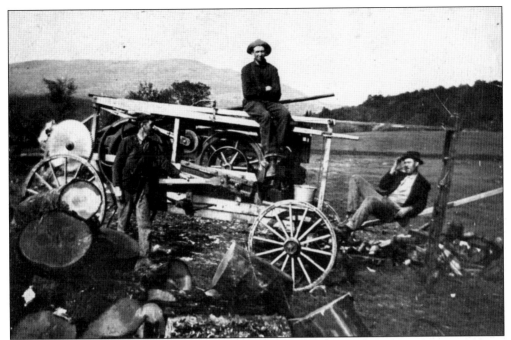

One use for a gas-powered circular saw like this one was to cut hardwood logs into shorter lengths for shipment to pulp mills and paper factories. Perhaps these men were gathering up cordwood for sale to homeowners.

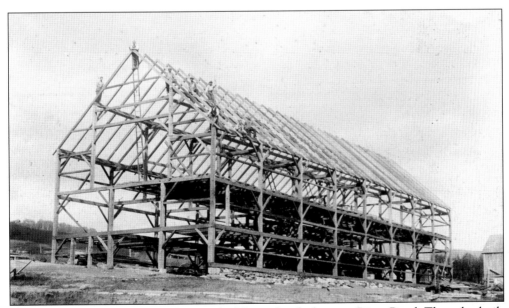

The Pipers built this barn in 1889 on the Norris family farm on River Road. They also built the Edgell Bridge and the old and new red Lyme schools. The barn is no longer standing.

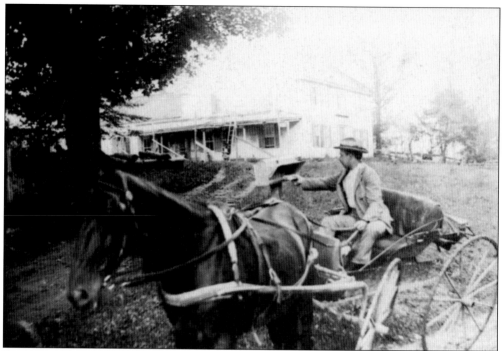

Foster Franklin, of the Franklin farm on River Road where Grant Brook meets the Connecticut River, delivered mail by horse and buggy. The mail was delivered twice a day for many decades.

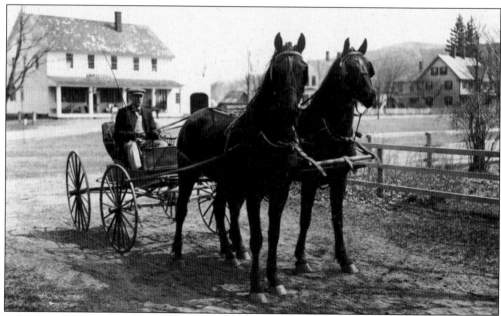

A horse and carriage round the common around 1905, after Fred Randlett purchased the store and opened a tinsmith shop in the building shown in the background. Fred learned the trade from his uncle, George Randlett, another Lyme tinsmith. Fred ran the store until 1934. Built in 1781, the structure was originally located at the north end of the common and was used as a meetinghouse.

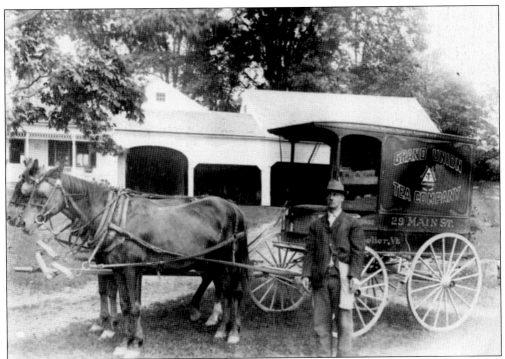

George Rowe, with wagon and team, delivers groceries in Lyme for the Grand Union Tea Company of Montpelier, Vermont.

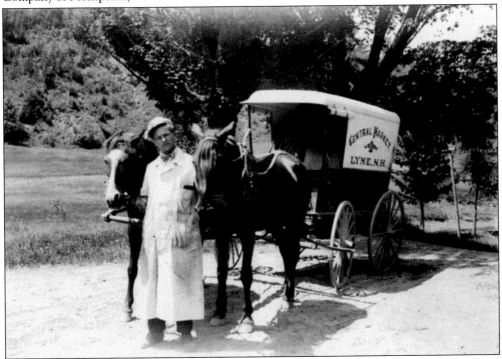

Ray Clough makes meat deliveries for Central Market. A slaughterhouse, operated by Elmer Blood, was located on Grant Brook at the bottom of Washburn Hill Road.

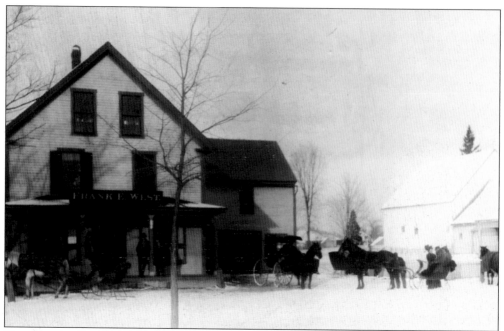

Note the sleigh and blanketed horse in front of West's, which is the store also shown on the book's cover. A building to the east of the store, near the back entrance to the Old Cemetery, operated at times as a furniture store and seasonally as a Christmas shop. The Lyme general store has been operated continuously in the same location since 1785.

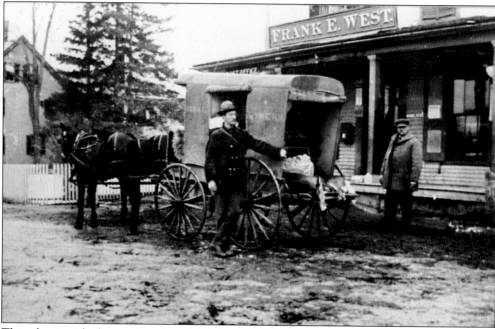

This photograph shows a horse and delivery wagon stop in front of West's (proprietors from 1906 to 1944). The two deer carcasses in the back of the wagon indicate that the store may have served, if not as a registration station, then as a place to show the day's take for hunters, as it does today.

Piper's Coffin Shop was originally located on East Thetford Road. It was moved in 1916 to its present location near the Lyme Congregational Church after the Brick School was torn down. It was used first as the central telephone office and is now owned by the Lyme Congregational Church.

This commercial building, which housed J. C. Piper, Dealer in Coffins, Caskets, and Robes, was located on the back side of the common. It was torn down in the 1950s. John Piper operated a sawmill behind this property and, at one time, stored lumber on the common.

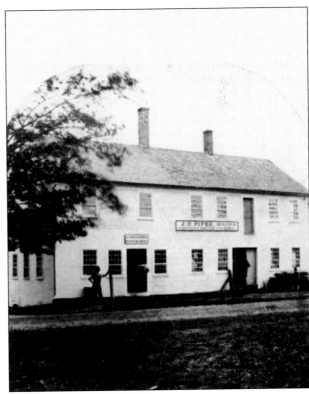

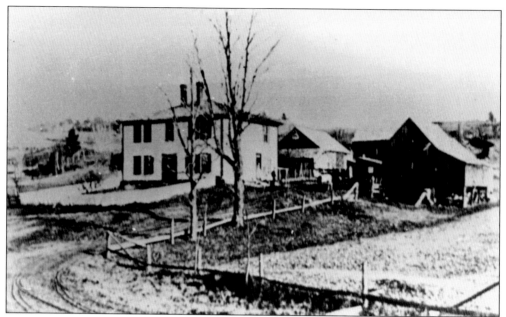

The Atherton Wales Tavern, east of Post Pond near Route 10, was built by Wales in 1797. It burned in 1907. The main roads through Lyme served as thoroughfares for trips to Burlington, Concord, and Boston, and the taverns along the way were frequented by weary travelers in need of food and rest. As many as 16 taverns were in business in Lyme at times during the late 18th and 19th centuries.

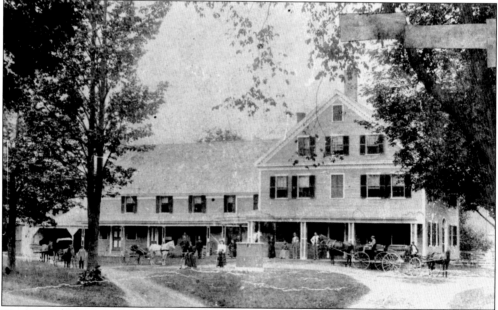

The Perkins Hotel was built in 1812 and was operated by the Perkins family until the 1870s. It was later known as the Hotel Warren. Many entertainments—family singers, demonstrations of glass blowing, and theatricals, for instance—were presented here, at an admission price of about 20¢. Located on Union Street on the site of the present Laura Barnes School, it burned in 1899.

Six

EVENTS

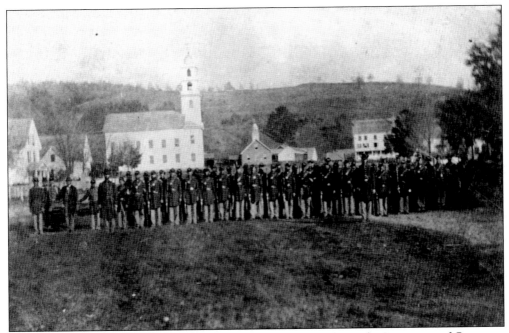

One of the oldest pictures in the Lyme Historians collection shows the Lyme men of Company A, 16th New Hampshire Volunteers, on the common in 1862. During the Civil War, 157 men from Lyme served.

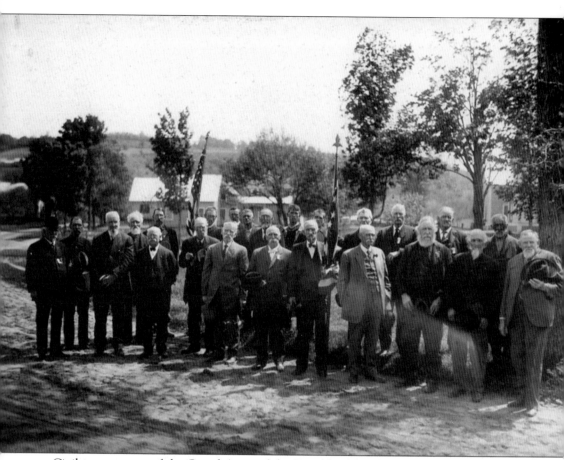

Civil war veterans of the Grand Army of the Republic (GAR) gather on the common for the Memorial Day ceremonies, around 1912. Washburn Hill is in the background.

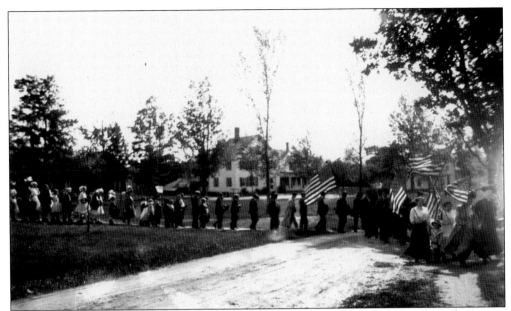

It became a Memorial Day tradition for the Women's Relief Corps to gather and make wreaths for the graves of each veteran in the cemetery. This picture, from about 1910, shows that on the day itself, after a church service, lines of veterans, members of the Women's Relief Corps, schoolchildren, and the general public would form. Children were given wreaths to place on each flag-marked grave.

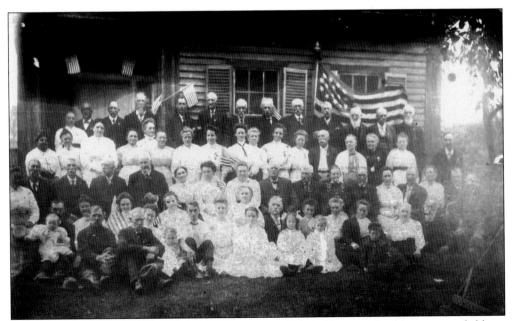

After the ceremonies, the veterans met at a member's home with their wives, children, grandchildren, and members of the Women's Relief Corps. In this photograph, the flag of the GAR is proudly displayed behind them.

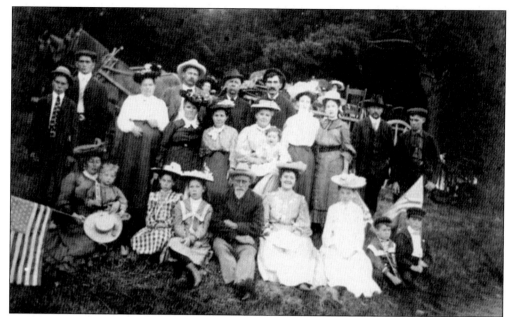

The Fourth of July was a favorite time for picnics, as shown here in about 1902. Pictured from left to right are (first row) Fannie Badger and her son, Mary and Marion Badger, Henry Badger, Amy Pushee Temple, Alice Winslow, Vernon Robeshaw, and Clarence L. Pushee; (second row) Jane Winslow, Clara Badger, Fannie Pushee, and Fannie Temple. In the third row are Carl Badger, Harvey Winslow, Mimmie Badger, Charles Robeshaw, Clarence Pushee, Leslie Temple, Nettie Badger, Ethel Pushee, Charles Badger, and Burt Badger.

The Pushee family is joined by friends and relatives for a picnic at Lake Morey. The three children in the first row are, from left to right, Harris, Blanche, and Nettie Pushee; and in the second row are David and Mary Pushee, Frank and Abbie Wilcox, Augusta and Harry Gilbert, Charles and May Gilbert, Ralph and Angie Dodge, and Minnie and Will Gentry.

These women and children gathered in 1918 for the annual Utility Club picnic at the Wests' cottage on Post Pond. The club was founded in 1914 "to promote usefulness among our members for the church and community of our home town, and to increase its social life." The club is still active in town and raises funds to benefit many local organizations.

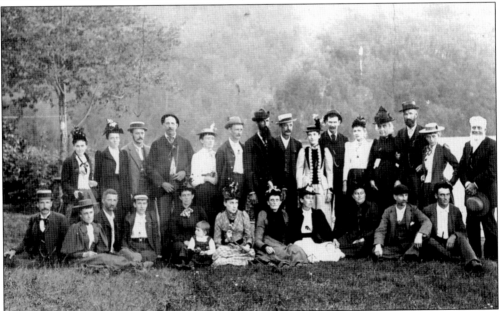

Only a few individuals were identified in this large group on an outing to Lake Fairlee. In the front row and third from left is Luther Whittemore, the woman with a child in her lap is Mrs. Weymouth, the eighth is Carrie Whittemore, next is Mrs. Hosford, and the last is Arthur Palmer. In the back row and third from left is Dr. Weymouth and the 12th and 13th are Mr. and Mrs. Fitch.

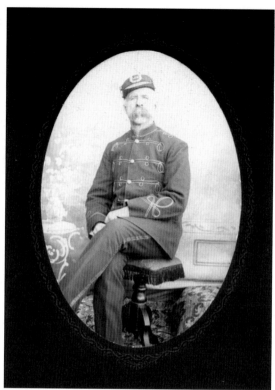

In this photograph, Clarence Pushee is dressed in his Lyme Cornet Band uniform. Native son Rhodolph Hall played his gold cornet for Queen Victoria, and his brother David played throughout New England.

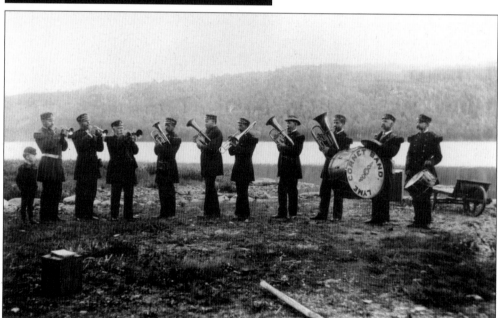

Village cornet bands were formed in many towns in the 1890s. Lyme's cornet band is shown warming up on the shore of Post Pond. Their music is resting on a box in the foreground, and perhaps the wheelbarrow helped carry the drums. Pictured are, from left to right, Dean Perkins, Edd Perkins, Arthur Palmer, Newton Perkins, Wilson Johnson, Frank Elliott, John Stark, Newton Wilmot, Fred Randlett, Clarence Pushee, and George Oakley.

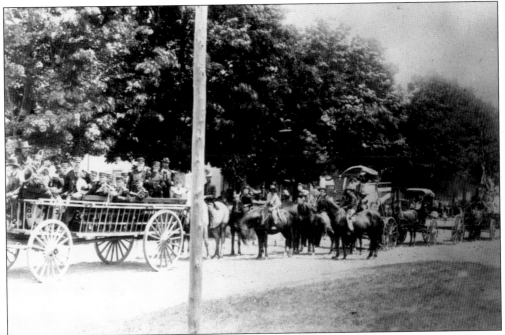

Many years ago on the Fourth of July, the band led the parade around the common riding in a large hay wagon. The Lyme Town Band still plays at parades and concerts.

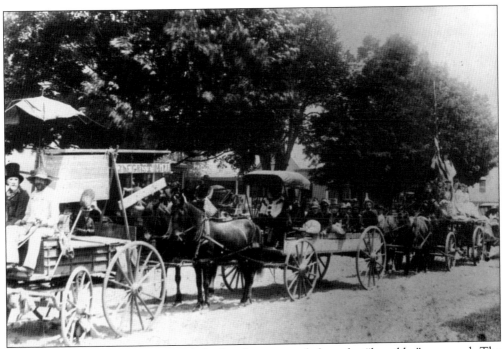

The Lyme Grist Mill cart followed the bandwagon, and then the "horribles" appeared. The horribles wore strange masks and garb and were a regular feature of Lyme's Fourth of July parades a century ago.

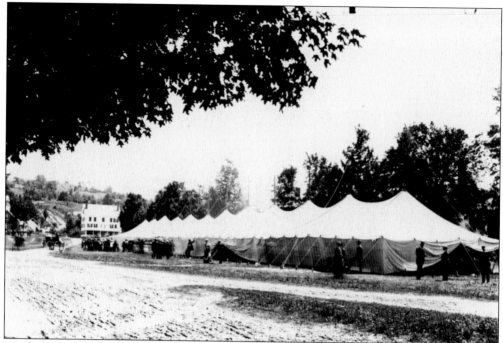

The biggest social event in Lyme's history was Old Home Day in 1885. The reunion was planned months in advance, and invitations were sent to friends and relatives far and wide. Orlando W. Dimick, a Civil War veteran and head of the Committee of Arrangements, urged them to "gather once more in the old town and live again the days of Auld Lang Syne."

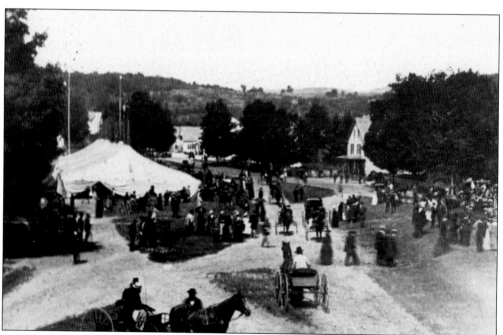

On the Saturday before the event, a tent 325 feet long and 50 feet wide was erected on the common. It stretched from the Lyme Congregational Church to Union Street.

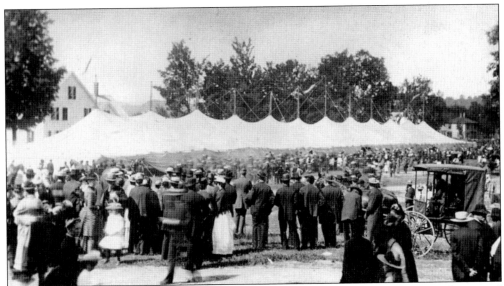

An estimated 3,000 people enjoyed the famous Hall's Band and a parade. An overflow crowd filled the church to listen to words of welcome, prayers, original hymns, and poetry.

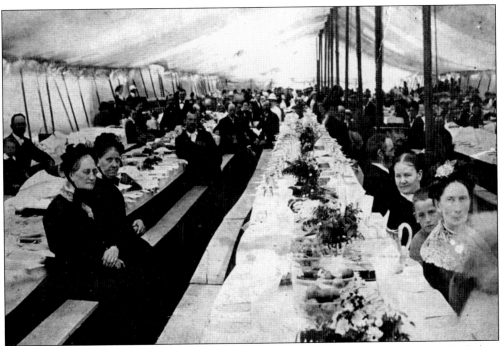

At 2:00 p.m. over 2,000 people were seated in the tent at long tables covered by 700 yards of white paper cloths. As reported in *Our Church Work*, "It was no small thing for the ladies of Lyme to provide food for between two and three thousand people. But they did it and they did it well."

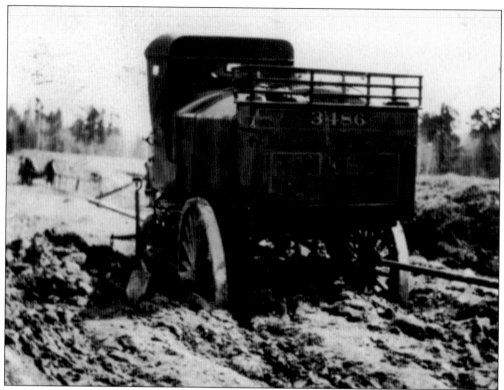

Mud season remains a perennial feature of life in Lyme. This photograph was taken in 1906 when an oil team became mired in the mud near Lamberts' woods on the East Thetford Road.

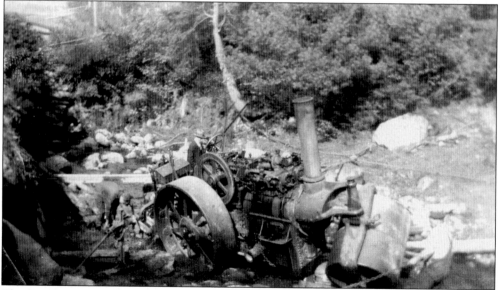

The Dorchester Road below Tannery Falls was being worked on in 1925 when a steamroller went off the road and into Grant Brook. Two men can be seen working to pull it out with chains and planks, but the man in the center seems too well dressed to be anything but the supervisor. Jennie Roberts, who lived nearby, took the picture.

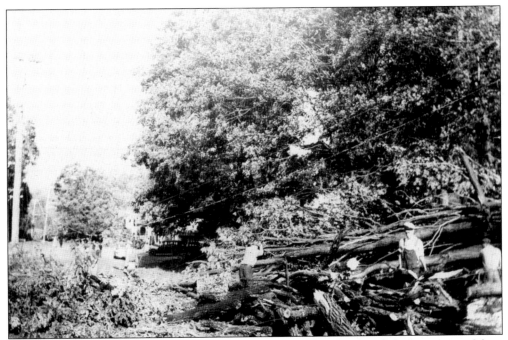

On September 21, 1938, a hurricane swept through New England with little warning. Many barns and thousands of trees were blown down. This picture shows the men of Lyme Center trying to clear Dorchester Road after the storm.

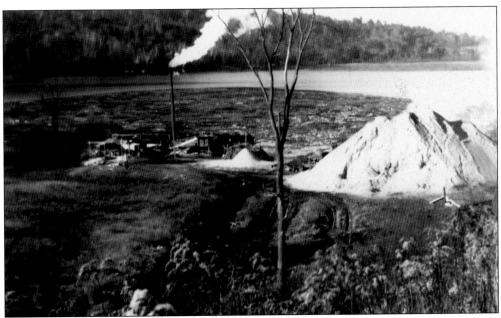

Post Pond was used to store the blown-down trees until they could be sawed. The logs were held in place with a long boom of chains. Guy Nichols set up a diesel-powered sawmill on the shore, and the pile of sawdust seen in the photograph indicates the huge job they accomplished. When the project was completed, 4.2 million board feet of lumber had been sawed. Glen Buzzell said, "It was like cutting wet towels."

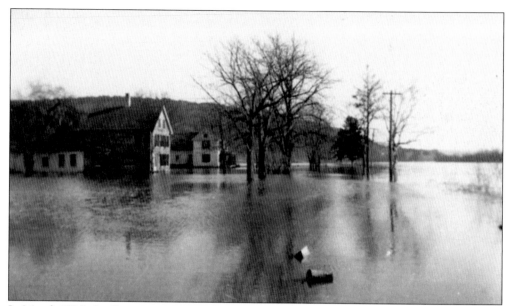

In March 1936, the Connecticut River flooded the homes and farms along River Road in Lyme. These homes were near the North Thetford Bridge. This photograph shows that logs are floating in the road between the trees and the telephone pole.

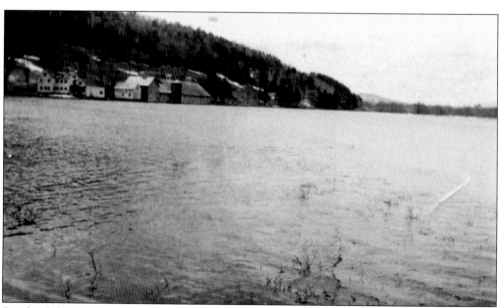

South of the East Thetford Bridge, Freeman Elliott, manager of the Norris farm, watched the river rise over the fields and into the house and barns. Then Charles Balch and his father rowed a boat down the road and into the barn to check on their neighbors.

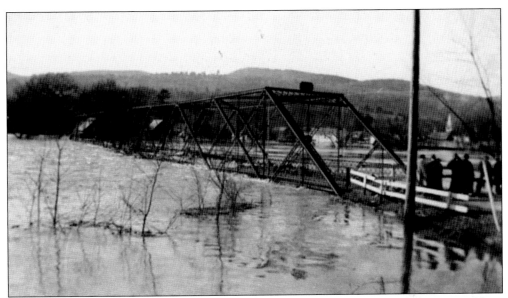

As the river rose from the flood and large chunks of ice started to break loose, neighbors gathered on the Lyme side of the North Thetford Bridge, hoping that the bridge would hold. Unfortunately it was badly damaged and cars could not cross for months.

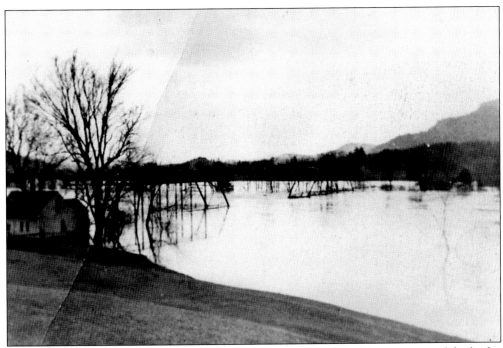

The East Thetford Bridge was damaged by the same flood, and the center section of the bridge was lost. Lyme and Thetford had developed into very close communities, and when both bridges were down neighbors had to go to West Lebanon or Piermont to cross the river. The Wilder Dam, built in 1950, now controls the river.

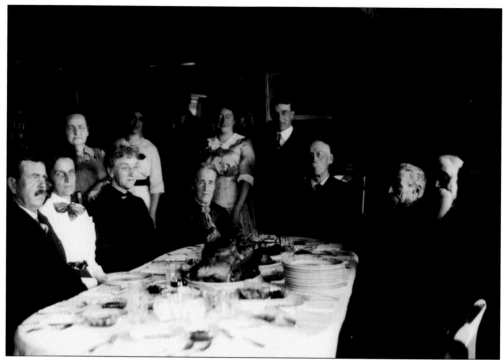

Mr. and Mrs. Blake (far left) joined 11 members of the Bartlett Mayo family for this Thanksgiving feast. The Mayos lived on a farm at the corner of Pinnacle and Orford Roads. Bart Mayo is standing in the doorway with his wife, May, on his left side.

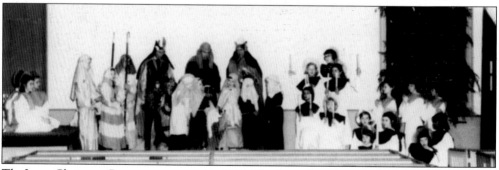

The Lyme Christmas Pageant was started in 1948. Members of nearly every family and organization in town took part in some way. In this 1953 group photograph, the cast is gathered around Mary, portrayed by Mrs. Manfred Bernhard, in the sanctuary of the Lyme Congregational Church. The pageant continues to this day.

Seven

RECREATION

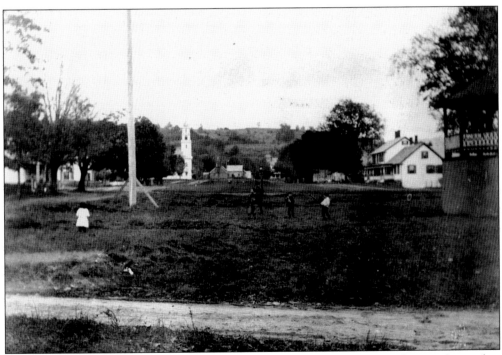

Never mind that the bats are taller than the boys, these youngsters are having fun with a pick-up game of ball on the Lyme Common. The photograph is undated but seems to be from around 1900. A lamppost marks the road that cut across the common east of where the cannon sits today.

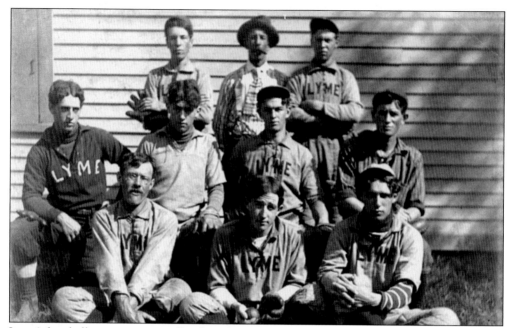

Lyme's baseball team poses in official uniforms around 1904. As one can see from the names, the team was something of a family affair. Pictured from left to right are (first row) Carl Steele, John Erastus Grant, and Leon Melvin; (second row) Harry Stetson, Henry Stetson, Ed Ware, and Frank Dike; (third row) Leslie Dike, Henry Dike, and Perley Ward. Lyme's most famous ballplayer was Libeus "Libe" Washburn, who pitched for the New York Giants around 1900.

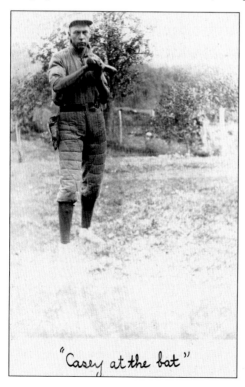

"Casey at the bat"

This dashing photograph of Perley Ward was put on a postcard. An admirer—or maybe detractor—labeled it after the 1888 satirical poem by Ernest Lawrence Thayer. Baseball was played on the common, including games against neighboring towns, causing occasional broken windows. By the 1920s, a larger playing area was used on High Street near the future Highland Cemetery.

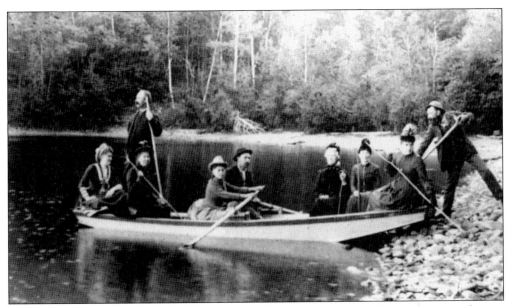

Boating was a popular recreation but no excuse for informality. The famous singer and voice teacher Madam Long, pictured here, second from right with the pole, was born Hattie Bond in Lyme. She joins friends for an outing on Lake Fairlee. Although she later lived and worked in Boston, Long returned to her "house by the lake" on Post Pond in the summers. For the Lyme Reunion in 1885, she sang her adaptation of "Auld Lang Syne," "We greet to-day our native place / Its hills and valleys fair."

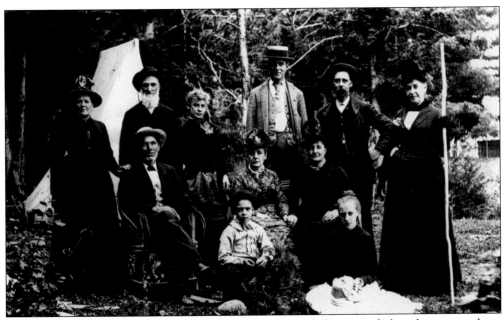

For another Lake Fairlee outing, Madam Long sports a different outfit but the same pole as pictured above. From left to right are (first row) Foster and Alice Franklin; (second row) Benjamin Newell, Lucinda Amsden, Delia Dimick; (third row) Mrs. Benjamin Newell, George Amsden, Henrietta Franklin, Harry Squires, Harris Dimick, and Madam Long.

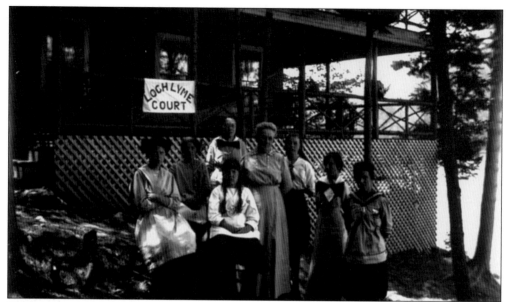

These teenagers at a Post Pond cottage belonged to the Queens of Avalon and were under the auspices of Mrs. Cowan (wife of John Cowan, who was the Congregational church minister from 1905 to 1915). The Queens were organized in 1908 and lasted until about 1924. Their purpose was "to help the church, to help others, and to have a good time amongst ourselves." In addition to Mrs. Cowan, this group includes Ethel Hewes Aldrich, Lenna Elliott, Isabella Rood, Mabel Cowan, and, in front, Marjorie Barron.

Then, as now, dirt roads can be challenging for cyclists. Young Ralph Flint does not seem perturbed as he cycles down Market Street past the Alden Inn probably in the 1920s.

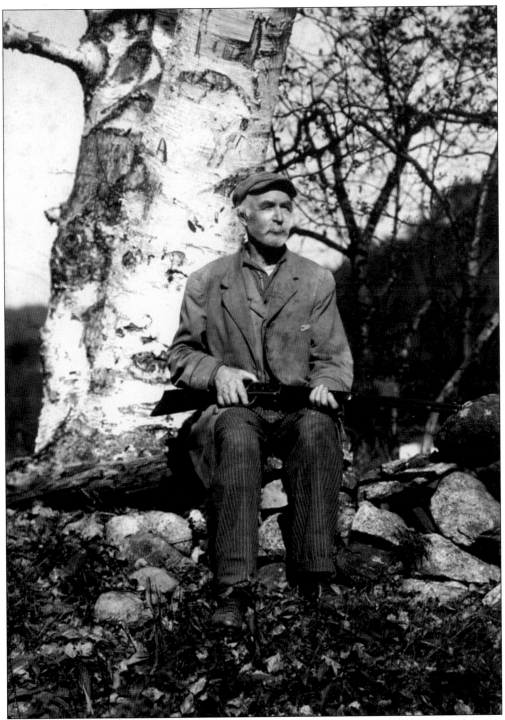

Walter King (1850–1916) poses with his gun in this photograph taken around 1900. He became Lyme's first rural mail carrier in 1905. Before ceasing to carry the mail in 1915, he made his deliveries in an early automobile, an International Chaindrive. His grandsons, Roger and Everett Rich, later owned the Rich Brothers General Store in Lyme Center.

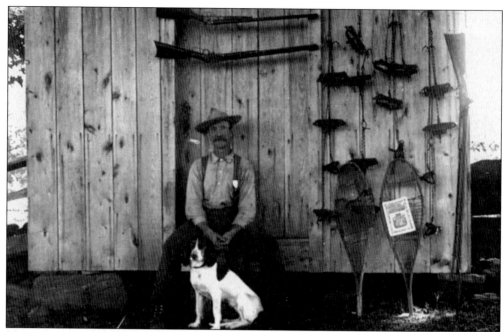

Bert Hewes, a farmer and well-known foxhunter, sits with one of his foxhounds around 1910. Bert was a direct descendant of Nathaniel Hews (the second "e" was added to the last name later), who was Lyme's third settler who built a house on Hews Lane around 1774. The dwelling still exists.

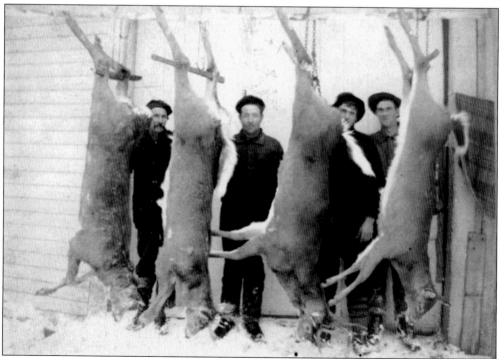

Lyme hunters Charles "Trapper" Dimick (born 1865), Ed Jenks, Arthur Sanborn, and Charles Lockwood show off two does and two bucks around 1906.

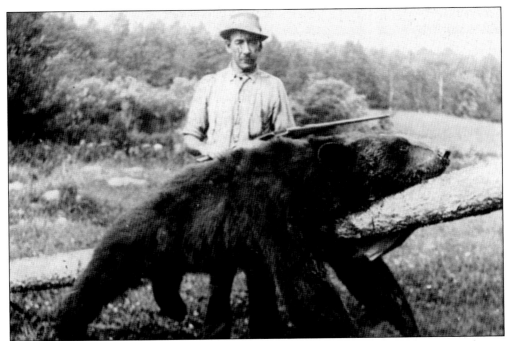

Clarence Gray propped his bear on a log to pose for a photograph. Gray lived up Dorchester Road just above where the Appalachian Trail crosses, but the house no longer exists. With so much cleared land, game was scarcer 100 years ago than now.

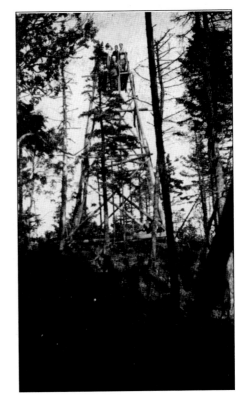

The top of Smarts Mountain has been a destination for hikers for many decades. Here, on August 4, 1917, a group has their picture taken at the top of the wooden fire tower that was built in 1915. For many years, Lyme residents served as lookout fire wardens.

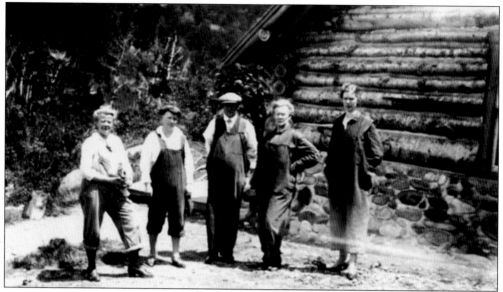

A group of hardy hikers, left to right, Ila Converse, Bertha and Fred Johnson, and two unidentified ladies, are shown here next to a cabin on the Smarts Mountain summit.

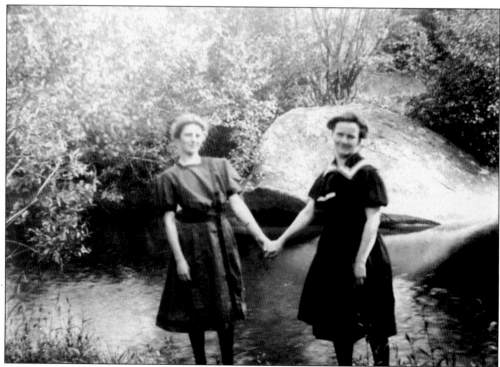

Leola McEwan Wilcox (left) and her mother, Dyanthia McEwan, are seen wearing their swimming dresses before taking a dip in Grant Brook. According to an account by Henry Wing, who moved to Lyme Center as a little boy in 1909, "Grant Brook was very good fishing . . . and a good place for swimming, either at the millpond or the old tannery hole."

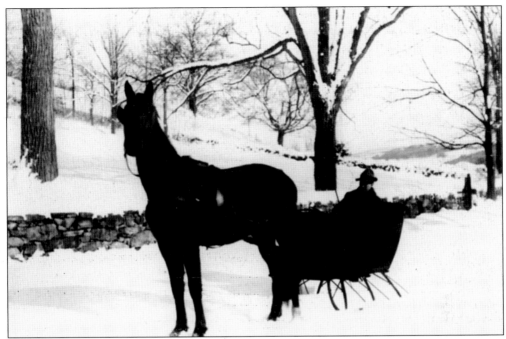

Whatever the season, Lyme residents always enjoyed a drive on a nice day. In the upper picture an unidentified man takes a sleigh ride. The roads were packed hard, not ploughed, making a nice surface for sleighs and sleds. In the lower picture, Mr. and Mrs. Ernie Waterman set out from a field on the East Thetford Road.

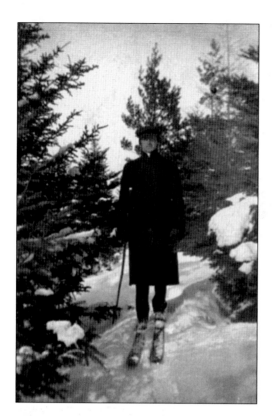

Skiing has been part of Lyme's history, and the lack of fancy equipment was no impediment in times past. In this photograph, the Reverend Edwin R. Gordon, minister of the Lyme Congregational Church from 1915 to 1919, ventures out on boards with one pole and excellent posture.

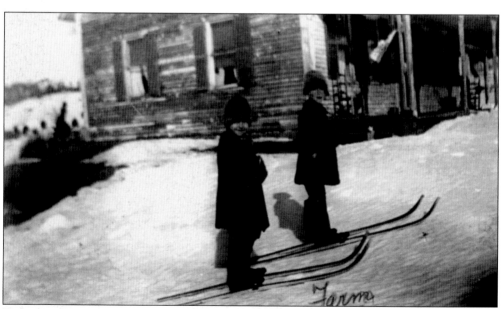

Everett and Roger Rich show off skis made by their father, John Rich, in March 1922. The brothers eventually followed in their father's footsteps in owning and running the Lyme Center general store. They were also active in Lyme's civic life for many years.

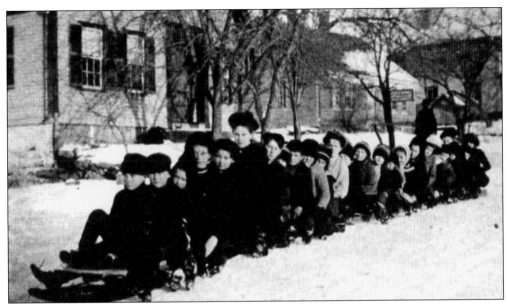

In 1905, this picture of Lyme Center students adorned the June souvenir program. Sledding was a big winter sport, and many first-hand accounts relate sledding down Baker Hill into Lyme Center, and from there all the way to the Lyme Common. Broken bones were not uncommon. Sleds were inventive and included "scooters" made by local blacksmiths, consisting of a single board mounted on a single cast-iron blade. These students may be on one or more "traverse" sleds, which were long boards with front runners that swiveled, and a set of back runners.

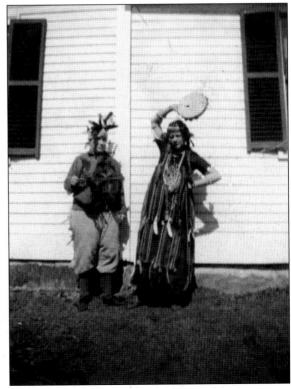

Sisters Ila and Hattie Lincoln are costumed for some event probably in the 1890s. Hattie taught school around 1900 before marrying Elmer Blood, the butcher. When she died in 1973, she was Lyme's oldest citizen. Ila married Sidney Converse, who farmed, operated the creamery, and left money for the Converse Free Library.

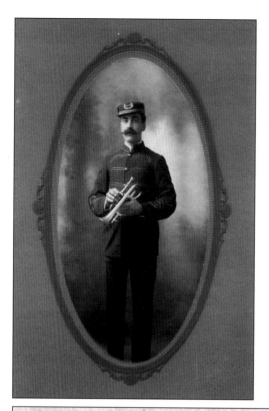

This photograph shows Bartlett Mayo (1879–1996) with his B-flat cornet as a member of the Lyme Cornet Band. Mayo was a farmer and a talented woodworker, played several instruments, gave music lessons, and in 1906, owned the first powerboat on Post Pond.

Yourself and lady are especially invited to be present at a

Private Dance

given at Morrison Hall, Lyme, N. H., February Twenty-one, Nineteen hundred and two. Dancing from eight to twelve. Music by the Grange Orchestra, led by Bartlett Mayo. Seventy-five cents per couple.

E. P. Pushee, Manager.

GOOD ACCOMMODATIONS FOR PUTTING UP HORSES.

To brighten long winter days, an invitation was issued for "Yourself and lady" to attend a dance on February 21, 1902, with Bartlett Mayo leading the Grange orchestra. Admission was 75¢, and "Good Accommodations For Putting Up Horses" were provided.

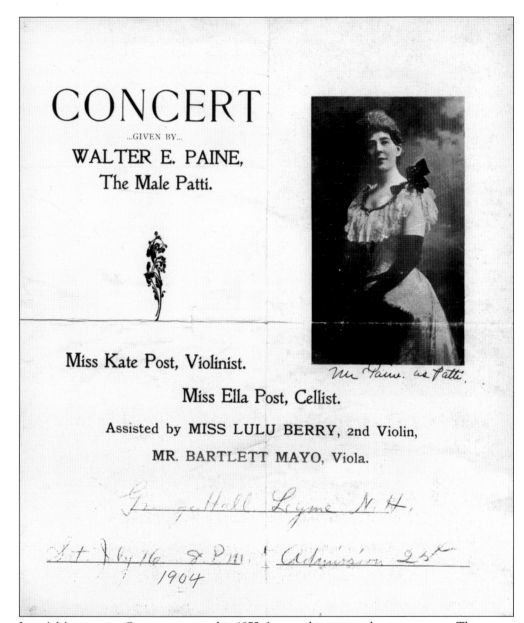

CONCERT

...GIVEN BY...

WALTER E. PAINE,
The Male Patti.

Miss Kate Post, Violinist.

Miss Ella Post, Cellist.

Assisted by **MISS LULU BERRY**, 2nd Violin,

MR. BARTLETT MAYO, Viola.

Mr. Paine. as Patti.

Grange Hall Lyme N. H.

St July 16 8 P.m. Admission 25¢
1904

Lyme's Morningstar Grange, organized in 1875, frequently sponsored entertainment. This poster advertises a somewhat curious concert for July 16, 1904, with a female impersonator, presumably a singer, and musical accompaniment by musicians, at least some of whom were local. Admission was 25¢.

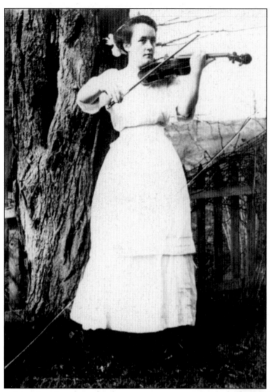

Musical instruments were in demand for home entertainment. Ida King, who later became Mrs. John Rich, posed outdoors with her violin in 1914 when she was 19. Her father was Walter King. Family records suggest she did not pursue the instrument very seriously.

Charles W. Canfield was a serious but not full-time violinist in Lyme who sometimes played for entertainment and dances. The 1886 *Grafton County Gazetteer* describes him as "violinist and blacksmith."

Sitting strategically in front of the stove, perhaps on a cold day, Bonnie Gilbert proudly shows off her dolls. Children had few toys compared with today, but did not seem deprived of entertainment. As Lyme native Charlotte LaMott said, "We had each other."

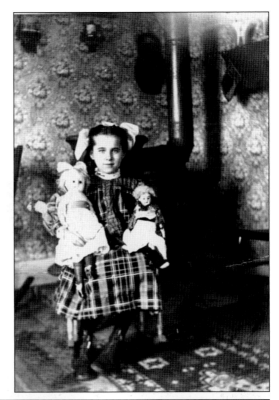

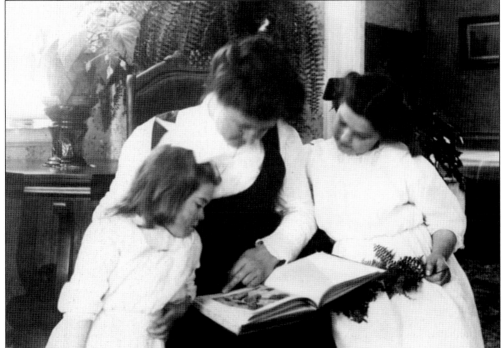

Children in the early 1900s had at least one thing in common with their counterparts of today: books. In this photograph, Amy Temple reads with Jennie (left) and Fannie.

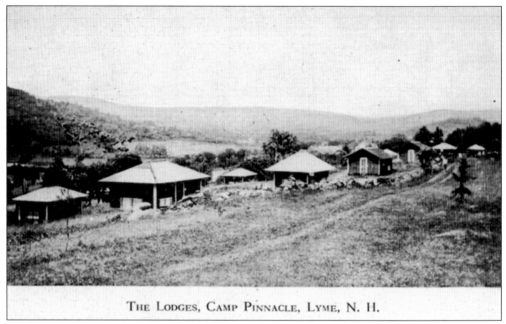

THE LODGES, CAMP PINNACLE, LYME, N. H.

From 1917 to 1981, Camp Pinnacle for boys was a fixture of the Post Pond scene and an important source of local employment. It was founded by Lyme resident Alvin Thayer, who ran it for 30 years and then sold it to Jerald and Alice Newton. This picture from the 1920s shows cabins on the camp's upper road.

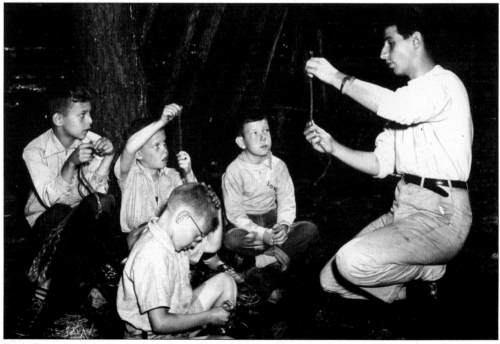

In addition to swimming, riding, archery, and many other activities, Camp Pinnacle taught boys skills needed for camping and canoeing trips. Pictured here in 1950, some boys looked a bit puzzled in their knot-tying class.

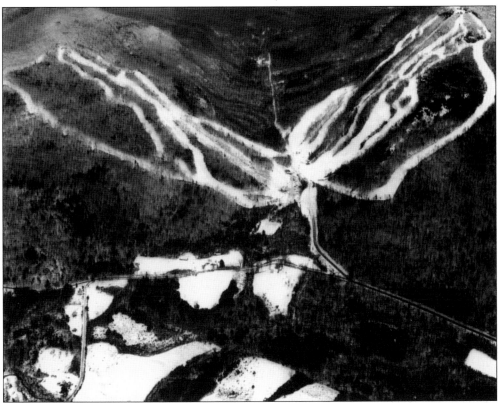

Ski lifts came to Lyme in 1956 when Dartmouth opened the Skiway on the slopes of Holts and Winslow ledges (above). Several generations of Lyme's Balch family played key roles in its construction, especially trail clearing, as well as other aspects of its operation in the early years. The lower picture shows the Balches, from left to right: Kevin Balch, Michael Balch, Raymond Balch, Barbara Balch, Ronald Balch, Mason Balch, Douglas Balch, Henry Marsh, and John Balch.

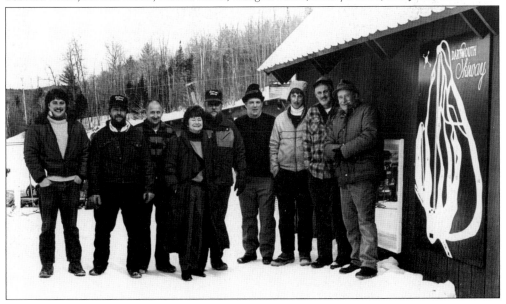

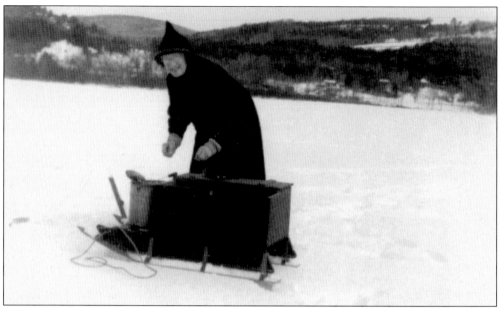

At 76, May Mayo, who lived at the corner of Orford and Pinnacle Roads, remained an avid ice fisherwoman and always used her special ice-fishing sled. She shows it off on Post Pond in 1960.

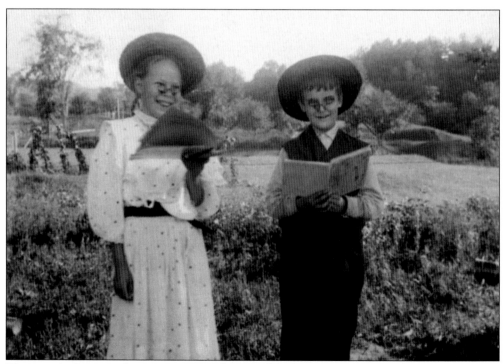

These young Lyme students are trying to bring to life characters in a story they are reading. In similar fashion, the pictures in this book help bring to life the story of Lyme's past.

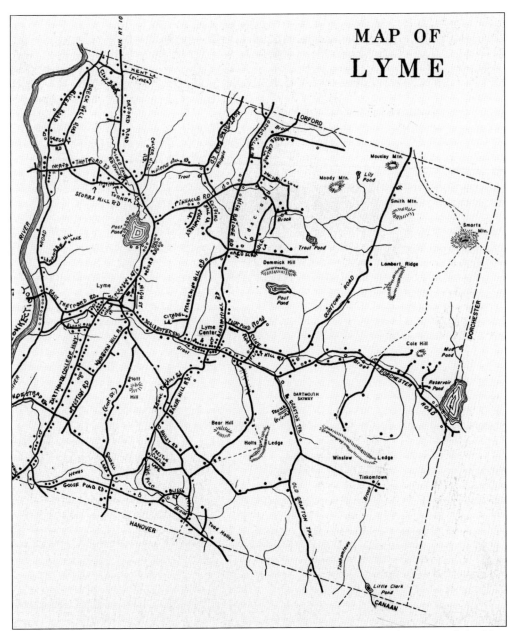

This map of Lyme is based upon Dr. James W. Goldthwait's 1925 map of Lyme, and the New Hampshire General Highway maps of 1935 and 1958 covering Grafton County.

Across America, People are Discovering Something Wonderful. Their Heritage.

Arcadia Publishing is the leading local history publisher in the United States. With more than 3,000 titles in print and hundreds of new titles released every year, Arcadia has extensive specialized experience chronicling the history of communities and celebrating America's hidden stories, bringing to life the people, places, and events from the past. To discover the history of other communities across the nation, please visit:

www.arcadiapublishing.com

Customized search tools allow you to find regional history books about the town where you grew up, the cities where your friends and family live, the town where your parents met, or even that retirement spot you've been dreaming about.